The Cape Cod
MURDER
of 1899

EDWIN RAY SNOW'S
PUNISHMENT & REDEMPTION

Theresa Mitchell Barbo

Charleston London

History
PRESS

Published by The History Press
Charleston, SC 29403
www.historypress.net

Cover image: Main street, Barnstable Village, often traveled by Jimmy Whittemore on his bakery rounds. *Courtesy of the Barnstable Historical Society.*

First published 2007

Manufactured in the United Kingdom

ISBN 978.1.59629.227.7

Library of Congress Cataloging-in-Publication Data

Barbo, Theresa M.
The Cape Cod murder of 1899 : Edwin Ray Snow's punishment and redemption / Theresa Mitchell Barbo.
 p. cm.
ISBN 978-1-59629-227-7 (alk. paper)
1. Snow, Edwin Ray. 2. Murderers--Massachusetts--Cape Cod--Biography. 3. Murder--Massachusetts--Cape Cod--History--Case studies. 4. Whittemore, Jimmy. I. Title.
 HV6248.S6133B3 2007
 364.152'3092--dc22
 [B]
 2007005211

Notice: The information in this book is true and complete to the best of our knowledge. It is offered without guarantee on the part of the author or The History Press. The author and The History Press disclaim all liability in connection with the use of this book.

For Richard "Dick" Barbo

CONTENTS

FOREWORD

In 1899, two lives ended on a small village road on Cape Cod. One was that of James T. Whittemore, a twenty-one-year-old baker's assistant who was murdered by seventeen-year-old Eddie Snow. Although Snow did not die until many years later, his life of unfettered freedom came to an end on that very same dusty road in September 1899.

There is a tendency for people of our contemporary era to romanticize the past and to demonize the present—that people were much kinder then, more forgiving and less troubled by violent crime. *The Cape Cod Murder of 1899: Edwin Ray Snow's Punishment and Redemption* forces us to reconsider these idyllic notions.

This book provides an illuminating glimpse into village life at the nexus of two centuries—the nineteenth and the twentieth—from horse-drawn carts to the era of the automobile. The murder occurred fully four years before the first transatlantic wireless communication was sent from a beach just a bit farther east on Cape Cod.

A person born and raised in the small village of Dennis at that time could expect their neighbors to be helpful, compassionate and forgiving. If, however, you came into the village as a "babe in arms," as Eddie Snow was, you would always be considered an outsider. However friendly the natives might be over time, there would remain a deep-seated distrust of, and a persistent refusal to forgive, any transgressor who was not genetically rooted in the community.

The reader will learn some surprising information about the Massachusetts prison system from 1900 to 1932 through the eyes of one of its longtime residents, and how a teenage thief and murderer was transformed into a mature, introspective adult.

As a forensic psychologist who has examined a number of murders on Cape Cod and surrounding areas over the years, I am always interested in uncovering the genesis of violence. I had assumed that each era produced its own unique

dynamics that generated antisocial behavior, and was therefore intrigued to discover that the roots of violence have not changed much over the last 107 years. The alert reader will find in Theresa M. Barbo's meticulously researched book a number of probable contributors to the crime: easy accessibility of a lethal weapon, the influence of violence-promoting media, genetic factors, inadequate adult supervision, feelings of mistreatment and rejection, a tendency to blame others, poor impulse control and a teenage rebelliousness against family and community values. It would appear that Eddie Snow was not that different from contemporary teenagers who are gunning down their peers in small towns across this country.

For his crime, Eddie Snow had the distinction of being the first person in Massachusetts to be sentenced to the newly developed electric chair. This is the story of a heinous crime, an outraged community, a teenage murderer and the punishment Eddie Snow endured for thirty-two years. It is, ultimately, a true story of redemption.

Ira Silverman, PhD
Forensic Psychologist
West Barnstable, Massachusetts

ACKNOWLEDGEMENTS

C omposing historical nonfiction is rarely a sole endeavor. Many professionals assisted in directing me to research sources, and I remain grateful and in their debt, especially to staff at the following libraries: the Town of Yarmouth, Sturgis Library, Boston Public Library, Barnstable Superior Court and Barnstable Law Library.

The Massachusetts Archives in Dorchester is one of the Commonwealth's hidden gems, where William Milhomme and Timothy M. Jones provided crucial assistance regarding Mr. Snow's prison and parole records. Attorney Richard Banks of the Parole Division of the Commonwealth Department of Corrections steered me in the right direction on a document search.

I am indebted to Ira Silverman, PhD, who composed the foreword, and to E. Josh Albright, who helped locate newspaper articles. John Sears Jr. of South Yarmouth told me the exact site of the murder. Nancy Thacher Reid of South Dennis shared historical notes on events of 1899. I am grateful to the Historical Society of Old Yarmouth, Dennis Historical Society and the Barnstable Historical Society, which granted permission to use images from their collections, although I regret that no images were available of the individuals about whom I have written. My thanks as well go to Peter Owens, PhD, University of Massachusetts Dartmouth, for his years of encouragement and support.

Most of all, my deepest thanks go to my children, Katherine Margaret and Thomas, who often patiently waited until Mom finished her work, and to my husband, Dan, for his support through the years.

1

FEW STRANGERS,
FEWER SECRETS

The first light of a September morning reached over Cape Cod to burn off the bittersweet chill of early autumn and embrace the towns in a climate crackling with vigor and purpose.

Yarmouth and Dennis, idyllic havens of communal gentility and perfection, resembled the postcard images of hardworking Yankees in a picturesque landscape of coastal scenery and country stores. Bass River, the longest tidal river in Massachusetts, flowed north from Nantucket Sound into the heart of Old Yarmouth, spilling into craggy tributaries and reedy marshes. Chase Garden Creek in North Dennis and Yarmouth Port abutted still marshes whose silence was broken only by the occasional shrill whistle of the Old Colony passenger train.

In the early morning light, merchants prepared for business as usual. T.T. Hallet opened the window blinds and unbolted the door of his apothecary on Main Street in Yarmouth Port. Osborne Snow's blacksmith shop opened soon after with its trademark black smoke belching from the chimney. The insurance office of Thomas Howes in Dennis Port, and Sears Livery in East Dennis, awaited customers, as did the local dry goods stores at the ready with barrels of flour, sugar and salt to help households provide for the coming winter.

In Yarmouth Port, Thacher Taylor offered new carriages for sale, and local fruit peddlers W.F. Howler and H. Lovell set out their pushcarts filled with perishable wares.

Dennis and Yarmouth owed their modest prosperity and self-sufficiency to the industry of their merchants and the labors of coopers, carpenters, cobblers, millers, civil servants, teachers, doctors and finally, the undertaker, among other notable professions.

Most families provided for their own household. There were few strangers and few secrets. Social clubs, churches, libraries and work-related societies reinforced the bonds among the townspeople of Dennis and Yarmouth. Each

time-honored association, whether large or small, provided its members with a sense of shared values and a network of lifelong friendships.

A Veteran's Lodge was founded in 1871 with members composed primarily of prominent citizens and civic leaders. Meetings were held on the first Saturday of the month in the South Yarmouth Masonic Lodge. The South Yarmouth Owl Club, reputedly one of the Cape's oldest all-male social clubs, had its "roost" at 11 Main Street, where Frank W. Homer presided as chief owl. Local tradition had it that the club got its name when a member's wife complained that the men were worse than night owls.

The Sabbath was faithfully observed throughout the community. The Congregational church, the faith of Cape Cod's first settlers, had been founded in 1638 and was the predominant form of worship.

During succeeding generations, Christian worship had grown to include congregations of Unitarians, and the Society of Friends, Swedenborgians of the New Jerusalem Church and strong followings of Methodists and Baptists spawned the Great Awakening movement. Few Roman Catholics lived in Yarmouth at this time.

Although nineteenth-century inventions and industrialization had some impact on the lives of Cape Codders, the Cape's physical nature had little changed. Its sandy landscape and homegrown architecture remained much the same as in the seventeenth and eighteenth centuries. In 1899, one could still stroll by the private homes and manses that were once the residences of Yarmouth's earliest families, or at least those of those clans' children.

Kettle ponds, carved by glaciers thousands of years earlier, were nearly as clean and clear as they had been eons earlier, although by 1899 icehouses and small fishing shacks dotted the shorelines that encircled them. Fortunate was the property owner whose land abutted the sea or freshwater kettle pond, with several acres of quality upland, dale and meadow for good measure.

The Cape's economy had long since shifted from the land to the sea. Along the shores of Bass River in South Yarmouth and West Dennis, and in Barnstable village to the north on Cape Cod Bay, packet ships ferried passengers and bulk cargoes of corn, lumber and flour to Boston, New York and ports along the Atlantic seacoast. By 1899, the heyday of square-riggers was long gone. Schooners and fishing boats still plied the waterway on Cape Cod Bay and Nantucket Sound.

Commerce thrived along the many waterfronts—docks, wharves, piers, inlets and coves. On any given morning in season, the harbor and estuaries were far from idle. On Cape Cod Bay to the north, and Nantucket Sound to the south, fishing boats ferried bantam crews across the water; with good luck, fishing nets would yield bountiful catches of mackerel, flounder and the ubiquitous cod for which Bartholomew Gosnold had named the peninsula.

From one generation to another, through all seasons, family blood and social ties connected people in Dennis and Yarmouth. Young men and women wed distant cousins or the daughters and sons of parents' friends. Newcomers were rarely welcome in the tightknit brood whose news, no matter how mundane, appeared in the *Yarmouth Register*, the weekly publication of record and the eyes and ears of the two towns since 1836, although at various times the paper had undergone name changes.

Each week, the *Register* tracked the comings and goings of Cape Codders, particularly those who lived in Dennis and Yarmouth. It was reported that Dr. Everett Hale's speech on "Peace," delivered on July 4, 1899, drew a large crowd in West Dennis. In addition, later that day all gathered at the home of Joseph Hedge for a picnic. That evening, Miss Sarah Whittemore of South Dennis was voted "most handsome" at the annual Fourth of July Ball held at Carleton Hall in Dennis village. The annual Barnstable County Fair was a social highlight of the year.

As the hazy days of summer melded into a crisp autumn, the *Register* reported that Jonathan Usher Jr. had settled into married life with his bride, the former Catherine Sarah Ferguson of Boston. Susie Haswell of West Dennis became the wife of Joseph Butler. That same month, news from West Yarmouth included the announcement that the Ladies Benevolent Society met with one of its most aged members, Mrs. Julia A. Crowell, who was approaching her ninety-first year.

The whereabouts, comings and goings of townsfolk provided fresh fodder for readers and each detail was scrupulously recorded. In its September 9, 1899 edition, the *Register* reported that "Mr. and Mrs. Albert Snow are spending a week in New Hampshire."

Cape Codders were not immune to the less than savory elements of human behavior. Indeed, moral infractions were printed in the *Register* near the winning recipes from the Barnstable County Fair. "Sylvanus Dill and Lucinda Higgins were sentenced to the county house of corrections for three months and 15 days for lewd cohabitation," the paper reported. Beneath the Cape's late Victorian–era gentility, evidence that members of these mid-Cape communities behaved in less than gracious and approved patterns was there for all to see in print.

The destitute did not escape the spotlight, either. The poor were shuttled to local almshouses and confined there as "inmates," imprisoned by poverty and lack of charitable assistance of neighbors. For these indigent men and women and their children, the Yankee work ethic had failed.

Then, as now, there were the foolish and the unguided.

On September 13, 1899, an individual known for idleness and dishonesty committed a crime that only the passing of fifty years would allow Dennis and Yarmouth to forgive and forget. The crime deprived a native son of Dennis his life, and doomed an adopted son of Yarmouth to a life of censure, humility and punishment.

2

BAD BLOOD

Edwin Ray Snow awoke inside the home of his parents on Main Street in Yarmouth Port. He had passed the night in a feverish state. Although he no longer lived with his parents, Edwin had come to stay at the family house to recover from severe dysentery and to nurse a hangover brought on by two weeks of drinking.

His parents, Albert and Ida Snow, were not home; they were vacationing in Glendale, New Hampshire. Although sick, disheveled and with no one to care for him, young Snow had larger concerns than his precarious health. He was unemployed and without any immediate prospects for work, and not for the first time. Ever an undisciplined and lazy fellow, Snow was a constant disappointment and embarrassment to his hardworking, stoic parents.

Edwin's immediate problem, among many, on the morning of September 13, 1899, was the need for quick cash, chiefly to buy a two-dollar train ticket to get out of town. Moreover, he had this gun, a pistol that belonged to his father.

Albert and Ida had adopted Snow as a small child. The story goes that he was an abandoned infant in Boston and placed in an orphanage there. Through family connections, the baby boy had come to live in Barnstable at the home of Mrs. Joseph Huckins, Ida's mother. Before Edwin had turned five, Mr. Huckins had died. Ida and her husband, a carpenter, themselves recovering from grief over losing two infant girls, gladly took Edwin in as one of their own.

For years, all seemed well. The Snows sent their boy to Yarmouth public schools where, by all accounts, Edwin did well, although no formal school records remain. He played with other boys—such as Charles Bassett across the street—and numerous cousins in the Snow and Huckins households.

Snow's solid childhood mirrored that of many boys like Charles Bassett and Edward Chase, who by 1899 had become upstanding young men with their own families to raise in Yarmouth. Edwin once wrote that "up until high school" his

life had never seen a shadow cross it, except for the time he was falsely accused of writing something naughty about a teacher on a basement wall.

Indeed, everything was fine, Snow said, until three months before he was to graduate from high school. "I passed all examinations easily, was captain of the team, secretary of the club, and was in no way set apart as cruel, degenerate or peculiar," he would write in his later years.

Snow described thick and strict discipline. "I was sent regularly to school and church, never allowed to associate with any wild companions, or lead any sort of loafing, street life. I was permitted all healthy and wholesome amusements; and granted all that any boy could wish for," Snow said. "Briefly, I grew up in a very normal, protected environment, and was liked, favored, respected as a 'gentlemanly young man'…In my thirteenth year I entered High School, with the purpose of later going to Harvard Medical School," Snow added.

Still, people would say there was always something strange about Albert and Ida's boy. No one let them forget their son was adopted and not a true native son of Yarmouth. Eddie was not right in the head, never would be, so the musings and mutterings went. "I have known him since he was two months old," observed one lifelong Yarmouth resident, "and there was nothing too bad or evil for him to do." Even with his ties to the Snow family name, a family with deep roots in Cape history, people regarded his mysterious origins with suspicion. Eddie was like a bad can of beans in the back of the pantry—no one knew how long those beans had been there, so they were afraid to open them, yet were hesitant to toss them away.

One of the first signs of trouble came when Edwin was sixteen. In February 1898 he allegedly broke into a local shop owned by two brothers and, according to Barnstable Superior Court documents, stole a revolver and a razor "of the goods and chattels" of Henry and Walter D. Baker. Although the item was worth a mere $2, the shameful notoriety of the theft for his adoptive parents was incalculable. Edwin was charged with larceny and a judge set bail at $200.

Some might have shrugged off the burglary as a youthful indiscretion, but they could not ignore Edwin's next escapade one month later. In March 1898, Edwin and a friend, Bert Raymond, were charged with stealing from a store owned by Mrs. Isabel Lewis, the sister of Mr. Albert Snow. Stolen, according to documents at Barnstable Superior Court, were "eight coins each of the denomination of one dime and each of the value of ten cents, one promissory note of the denomination of one dollar. Ten ounces of cologne each ounce the value of ten cents."

Young Edwin also swiped three pounds of candy. Snow was arrested by Yarmouth Patrolman Seth Taylor and taken to the county lockup. His father asked a wealthy family friend, Clarendon A. Freeman of Chatham, to post the $500 bail. Snow was free, for the time being. When Edwin appeared at

Barnstable Superior Court on April 13, 1898, to answer charges of larceny from the Baker's store and of breaking and entering Mrs. Lewis's shop, Edwin pled not guilty to both charges. Despite his innocent plea, a Barnstable grand jury indicted him on the breaking and entering charge. The larceny charge was stayed.

Edwin would insist to his dying day that the breaking and entering charge was a setup. He claimed that a state police officer had "engineered" the setup on behalf of Mrs. Lewis, his aunt, insisting that she was "trying to settle a family grudge" over an inheritance. Snow later admitted that he had given "information about the store to the parties who did the actual act."

Guilty of complicity, at the very least, Snow's claim of being "set up" would be only the first time in what would become a lifelong pattern of projecting denial and blame on others for his own actions.

Following the indictment, Assistant District Attorney M.R. Hitch pressed for a swift and severe punishment. The judiciary did not disappoint Hitch. In April 1898 a judge ordered young Snow "forthwith to be delivered into the custody of the Superintendent of the Massachusetts Reformatory at Concord" in Middlesex County. The facility was, according to records at the Massachusetts Archives, intended for boys "who have committed criminal acts rather than fallen into criminal habits and who need the elevating influence of a reformatory."

Barnstable County Sheriff John J. Harlow and Edwin Ray Snow arrived at the Concord Reformatory the morning of April 2, 1898, and officials there quickly processed Edwin into the system. Edwin had brought an overcoat and suit. He also wore handcuffs.

Eddie served ten months at the Concord Reformatory, although the term on his intake record was listed as "no longer than 5 years." If not for a kindly judge, compassionate corrections officials and "good behavior," Snow might have served the full length of his sentence. Interestingly, several other young men—petty thieves like Edwin Snow—were processed into the system at Concord Reformatory the same week as Eddie's arrival, and they, too, were given terms of "no more than five years." It is easy to conclude that the five-year timeframe was a standard length of punishment for youthful offenders, though the sentence could be reduced for good behavior.

Edwin had an unblemished record at the Concord Reformatory; he did all work assigned him and caused no trouble. Most of Eddie's fellow thieves were, like young Snow, released after ten months.

Edwin's remembrances of the Concord Reformatory are of a promising teenager nearly out of high school who was falsely accused of a crime he did not commit. "Three months before graduation, I was arrested on my way to school, taken over to the county court house, and accused of breaking and

entering a store kept by a sister of my father." Edwin's account composed in 1930 matches his past versions of his spiral into delinquency.

"Another boy, arrested with me, proved in one hour he could not have been there. A third boy, also charged with the break, was out fishing, and because he was along he had to face trial with me," claimed Edwin. "The whole mess was a setup engineered by a state police officer, for an aunt who was trying to settle a family grudge," Edwin insisted many decades after the fact.

"The nine-year-old boy whose testimony convicted us, despite the fact that he had nothing to do with the affair and could not name or produce an article taken, was believed," Snow remembered. Edwin also claimed in his 1930 autobiography that the boy tried with him paid no price. "The judge gave the other innocent chap probation, and while in Concord the district attorney received evidence that proved my innocence—too late to give me redress," Edwin stated.

Albert brought his son, Edwin, home to Yarmouth in the spring of 1899. Once home, Edwin could not or would not return to school. "My mother engaged the principal of the school as a private tutor," Edwin wrote in 1914. Edwin eventually earned his high school diploma and worked as his father's carpenter's assistant, earning two dollars per day, the only work young Snow could find in Yarmouth.

Edwin became the village pariah. Other than working for his father, no one hired Snow. He realized that life as he knew it would never again be the same now that he was a branded thief and had served time in a reformatory. The only people in Yarmouth who wanted him around were his parents. For the young outcast, work was tough to find and so were friends. After two weeks, Edwin decided to pack his bags and move on. Feeling ostracized and with no job offer in sight, Edwin broke a vow to himself made at the Concord Reformatory never to leave Yarmouth again.

In March 1899, just after turning seventeen, young Snow moved to Middleboro, Massachusetts, to the care of his mother's younger sister, a beloved aunt named Ellen "Nellie" Whittemore. Middleboro was a small town within reasonable distance of Cape Cod. In the late nineteenth century, Middleboro was a terminus for the Old Colony Railroad. In the past, Edwin had often bought a ticket and traveled to Middleboro to visit his aunt, uncle and cousins.

At first, Middleboro seemed the perfect haven for Edwin. His uncle found Snow employment. From March to September, Edwin held several jobs in a printing office, a shoe store and a machine shop. It is not known why college was not an option for Edwin, who once harbored thoughts of medical school.

"Her husband procured a start for me in a printing office, introduced me into circles of the Baptist Church and YMCA," Edwin wrote in 1919. "From then on I had no idea or impulse to commit crime, until in some way it became

known I had been in jail." Word about Edwin had followed him to Middleboro from the Cape. Still, he did his best to belong to his new community.

It would have appeared to those closest to him that Edwin's checkered past was well behind him. He would later say of those months in Middleboro that not one person mentioned the Concord Reformatory, although it is certain his relations, especially his aunt, knew of his past. No doubt, Edwin himself thought his troubles were far behind him.

What had begun as a fresh start soon smelled like a bad egg. Signs of trouble emerged. In his renewed zest for fun, Edwin appeared to have enjoyed life too much. He squandered money on good times, such as the theater and haunts of youth. The odd jobs he held did not pay enough to cover his fresh amusements, leaving him no money for room and board with his aunt and uncle and no prospect of earning enough to stave off debt.

"It is true that I staid [sic] out late some nights, and in showing off spent more money than I earned" while living with Aunt Nellie in Middleboro, Edwin confessed. "But I did not steal, lie, drink or get familiar with girls. My peccadilloes were a minor form of wild oats. My debts, that I was ashamed to confess, caused me to commit one case of larceny."

Edwin was suspected of having burglarized an unlocked shop and taking cash receipts from the money drawer. No charges were filed, but the suspicions were laid as firmly at Edwin's feet as the path shown to him out of Aunt Nellie's home. Here Edwin finally admitted to a crime for which he was guilty. Even though he was not arrested, he remained a prime suspect in the theft and was asked to move out. "I was obliged to leave town," he remembered.

Edwin moved back to Yarmouth Port where, for less than a month, he lived with his parents and worked for his father, earning two dollars per day as a carpenter's assistant. The last time Edwin had worked for his father he had just been released from the Concord Reformatory.

A few nights after his return to Middleboro young Snow heard his father crying in the next room, presumably about Edwin's latest escapade, the recent theft of the money drawer in the unlocked store. To cover himself and to ease his father's suffering, Edwin made up a story about buying clothes with the rent money.

The pressure and social scrutiny Snow had experienced resurfaced—the stares and small-town talk left Edwin feeling that he had no recourse but to again leave Yarmouth Port. Therefore, off he went from his home village to live on his own in Taunton, not far from his aunt's home, where he hoped to support himself with odd jobs.

By chance, Edwin had traveled from Taunton to Yarmouth in September 1899 for a surprise visit with Albert and Ida just as they packed for a trip to visit friends in New Hampshire. Edwin's sallow pallor was not lost on his mother.

She offered to cancel the trip to look after him. When Edwin would not hear of it, Ida arranged to have Mrs. Joseph Bassett, a neighbor and mother to one of Edwin's childhood friends, keep an eye on her wayward seventeen-year-old.

A day after Albert and Ida left town, Edwin told Mrs. Bassett that he thought he would head back to Taunton to work in the machine shops. Yet a few days later, he was back in Yarmouth.

"I asked him where he had been," Mrs. Bassett recalled. "He replied, 'I've been visiting my Aunt Nellie at Middleboro until Sunday and then I went to Taunton for a day or two. They told me I wasn't strong enough to work, so I came back.'"

In fact, Edwin had done more than visit Aunt Nellie. Another scheme had unfolded. He had gone to a baseball game, a sport he would love his entire life, and there he had met a man with, as Snow recalled years later, a "shady reputation." Snow identified him only as "C." Together, Edwin and "C" plotted to rob a Bourne horse dealer who was known to carry rolls of cash. "We agreed to knock him out, stun him to get his money," Snow later testified.

However, the mysterious "C" never showed up at the rendezvous on a train leaving Buzzards Bay on the morning of September 12. Instead, Edwin alone watched the horse dealer get off the train at the Bourne depot, his cash roll safely tucked into a deep pocket, and walk into the station. Without an accomplice to help with the robbery, Snow chose not to get off the train. Instead, he stayed on the train until reaching Yarmouth Port.

Edwin slept at his parents' home that evening, having let himself in with a key from a nearby store where Albert and Ida kept the spare. The next morning, he put on a checkered suit and left the house in search of someone who would lend him money for train fare back to Taunton.

He twice tried to borrow the money for the train ticket. First, he asked his former high school teacher for a loan but the educator declined, claiming he had no loose change. Snow then hit up his father's brother for money but Uncle George Snow, who lived in Barnstable, claimed his wife had taken his purse shopping.

Edwin was flat broke and desperate.

He stood alone in his uncle's yard and tried to plan what to do next.

THE NATIVE SON

Young Jimmy Whittemore was up and out of his family's home on Main Street, South Dennis, before the rooster crowed at Herbert Baker's neighboring chicken farm, and well before Edwin Ray Snow rose from his tormented slumber two villages over. With determined gait, Jimmy headed off to work at Rufus Gage's bakery in West Dennis.

Along the way, he passed Mrs. Mary Fisk's boardinghouse, Charles Underwood's boot and shoe repair shop and a dry goods store owned by Charles and Watson Baker.

The twenty-one-year-old had lived in South Dennis all his life and everyone in the village knew him. The son of James Lloyd Whittemore and Idella Rogers Whittemore, he was one of seven children in the ninth generation of a Cape Cod family that claimed Thomas Whittemore, born in 1594 in England, as an ancestor.

Jimmy was in his prime as a young adult on the brink of a life of possibility. According to those who knew him, young Whittemore was blessed with a strong constitution and a good heart. His father, a fruit peddler, had died of "paralysis" only two months earlier, leaving his wife, Idella, with few options to provide for her children. Circumstances had forced Jimmy, the eldest child at home, to bear responsibilities for his widowed mother and four younger siblings, responsibilities that were more commonly borne by men several years his senior. Without his wages, it is likely Idella would have ended up in the Dennis Almshouse.

It is assumed she relied heavily on her son's paycheck with some assistance from her two married sons, Henry and Clarence, since only the most meager savings would have been available to the widow of a fruit peddler.

Jimmy was a good son and quickly assumed the mantle of provider. He found work driving Rufus Gage's horse-drawn bakery wagon on a regular route from West Dennis, a village that hugs the banks of Bass River to the east, into Yarmouth and Barnstable to the west.

It is unknown whether Jimmy felt overwhelmed by his responsibilities as a breadwinner. Whatever his thoughts as he delivered cakes and breads to homes along the dirt byways, surely Jimmy was not the first Cape Cod boy to support a fatherless household in those days.

Hauling baked goods from town to town for the better part of the day, nearly every day, required physical stamina, reliability and diligence. Above all, since he was responsible for collecting and carrying a tidy sum of the bakery's cash receipts, the driver had to be honest. By all accounts, the tall, lanky Jimmy Whittemore mastered the job quickly, earning the trust of his employer and wages sufficient to support his family.

By the middle of this crisp September 13 morning, Jimmy was well along on his bakery route. It was a sunny day, which meant he could easily maneuver his horse and wagon on the dry dirt roads rather than driving along muddy roads and rutted streets softened by sheets of rain. Traveling west on Main Street in Yarmouth Port, then into Barnstable, Jimmy came upon a distant cousin related by marriage, seventeen-year-old Edwin Ray Snow, who had until recently lived in Middleboro with his Aunt Nellie and her husband, Hiram Whittemore.

Edwin climbed into Jimmy's cart and off they went. Although related through marriage the two young men had never been close. They had not seen one another in a year and a half and probably had enough to talk about while Jimmy drove his usual delivery route.

Jimmy and Edwin traveled for several hours, following the road to Hyannis, then back toward West Dennis through Barnstable and Yarmouth Port. It was a familiar journey to Jimmy, who had traveled the route countless times.

Jimmy worked while Edwin hung in the baker's cart. Throughout the day, Eddie stayed in the passenger seat whenever Jimmy hopped off to tote rolls, breads and baked goods to the doors of customers. At each stop, young Whittemore would collect cash, putting the bills and silver in a small bag in his shirt pocket.

During the morning hours, many villagers saw Jimmy and Edwin together. At noon in Barnstable, Jimmy fed his horse at E.S. Carr's. About the same time, Israel Sears, a fruit peddler, talked with the pair. Jimmy told Sears that business was slow.

Later that afternoon, Eddie and Jimmy headed into Yarmouth, probably passing the house where Mrs. Ellen Howes was hosting a fancy tea at her home on Main Street in Yarmouth Port. Nearby, also on Main Street, Jimmy sold a cake to Reuben Howes, an auctioneer, and soon afterward sold a loaf of bread to Mrs. E.B. Dearf. By day's end, Jimmy had collected a tidy sum, enough money for more than just one train ticket to Middleboro.

More than a few people thought it odd to see the two young men paired up. "Mrs. Dean, who lives near the entrance to the South Yarmouth woods, said she bought some cakes of Whittemore, and when he drove away she exclaimed, 'Well, what in the world can Eddie Ray be doing on that team with Jimmy Whittemore?'" reported the *Boston Daily Globe*. As twilight approached, F. Lincoln Robbins saw Jimmy and Eddie Ray pass his house in a horse-drawn cart. Robbins's home was the last before the road veered into the thick woods that separated Yarmouth Port from South Yarmouth. Robbins would later state that there had been "the young man on the front seat of the wagon and laughing and fooling with Whittemore" when he met them at 5:30 p.m., according to the *Boston Daily Globe*. Robbins also told a reporter that the young man in the checkered suit had given his little girl a piece of cake while Whittemore was making the sale, and that she identified Edwin Ray Snow as that man.

There were only two witnesses to the next chain of events—Edwin Ray Snow and Jimmy Whittemore—and only Edwin lived to testify. According to his story, after leaving Robbins's house behind, Eddie pulled out his father's old pistol in his pocket and demanded the cash Jimmy had collected on his route. "I rode around all day with a baker's delivery boy," Edwin recalled. "Going through a lonely wood in the late afternoon I put up the gun like a bold bandit in a dime novel." When Jimmy refused and lunged for the gun, Eddie shot

Jimmy in the head. He fired a second time and Jimmy tumbled out of the cart, his body spilling into the woods at a spot barely visible from the road.

The young Whittemore, sole supporter of his mother and siblings, was dead before his body hit the ground.

"He was older, larger, thought I was fooling, grabbed for it, and I pulled the trigger," Snow reasoned years later. "He sprang up, from some muscular reaction, and that scared me, and I fired again," Edwin added.

"My God, what have I done?" Edwin said of his first thought following the shooting. In a panic, Snow jumped off the cart.

Edwin remembered grabbing the bag of silver coins that had dropped in the road. Spooked by gunfire, the startled horse bucked and reared, dragging the wagon wheels over Jimmy's body and carving grisly ruts into his head and shoulders. The horse sped off, spilling breads, cakes and rolls into the dirt from the shaking cart.

"I could not look at his body; I did not touch his own money, bills or watch," Edwin wrote nearly thirty-one years later. "If there is a definite why to this act, I can't explain it."

Swiftly Edwin fled into the evening shadows. Years later, he would testify that he went back to retrieve the gun which was used to murder Jimmy. Less than thirty minutes after killing Jimmy Whittemore, Edwin made his way to the Bassett home. When asked where he had been all day, and what he had done, Edwin replied he had visited his uncle in Middleboro. Particularly odd, however, was a statement he made to Mrs. Bassett to explain his presence in Yarmouth. "I thought if I stayed here all night and anything should happen in town, I could be traced as being either here or at the pool room," Snow said. "Because if anybody here should be robbed, people would think of me first thing and say 'There's that Eddie Ray. He did it.'"

Mrs. Bassett found Edwin's declaration odd at best, but she invited him to stay for supper. He ate very little and acted strangely at the table. Then, in an unusual act of consideration, Edwin volunteered to walk Mr. Bassett home from his barbershop. After Edwin and Mr. Bassett arrived home, Edwin went to bed. His ploy to distract the household succeeded. Mrs. Bassett thought nothing more of Edwin's earlier peculiar remarks and behavior. The following morning Snow slept in late and almost missed the train to Middleboro. That was the last Mr. and Mrs. Bassett saw of Edwin Ray Snow and, as Mrs. Bassett later testified, "To tell the truth, I was happy at getting rid of him."

Within an hour of the shooting, L.A. Chase, a local shoe peddler, was driving his wagon along the route followed by Jimmy Whittemore when his horse suddenly shied and appeared in distress. He forced the horse on its way. The next morning Chase would learn that the horse had balked at the pool of blood draining from the corpse of Jimmy Whittemore.

3

TRAIL OF GUILT

There were no traces of daylight left in the sky when Ebenezer "Eben" Hamblin, a farmer and cranberry grower, took notice of a horse and wagon near his Yarmouth Port home down the street from Albert and Ida Snow's place. Eben's curiosity was aroused, as the wagon driver was nowhere to be seen. Hamblin was not particularly alarmed; perhaps the owner would collect the animal and its wagon tomorrow. Hamblin decided to board the horse overnight in his barn, and promptly unharnessed, fed and bedded down the animal.

Had he put a lantern to the wagon, he would have discovered a pool of blood beginning to congeal near the driver's bench. As it was, the bloodstain went undetected until morning.

As the evening of September 13 wore on, Idella Whittemore grew increasingly anxious. By midnight, she was sick with worry. Jimmy had told her he would be home early to prepare for a night out with friends. It was not like her son to change his plans or stay out late without informing her first. When she could sit idle no longer, Idella left her home in South Dennis, leaving her young children asleep in their beds, to search for Jimmy. She went to the home of Captain Rufus Gage, Jimmy's employer, in nearby West Dennis.

Idella reached his house and banged on his door despite the late hour. Captain Gage attempted to reassure her; he guessed that the bakery cart had probably lost a wheel and Jimmy had stopped somewhere for the night. Gage's speculation was not outlandish. Occasionally Jimmy had gone straight to the stables after work instead of checking in with his boss. A frantic Idella had little choice but to go home and wait for word of her missing son.

At daybreak on the morning of September 14, Joseph Bassett set off to work, while under the same roof Edwin Ray Snow prepared to head off to the train depot. About the same time, Charles Howes, a traveling salesman from Fall River, passed through the South Yarmouth woods but saw nothing out

of the ordinary. A little later that morning, Idella drove into Yarmouth Port from Dennis along her son's usual route. She was said to have stopped at many homes along the way to inquire about Jimmy. She passed through the South Yarmouth woods into Yarmouth Port, but saw nothing strange along the way. She may have even passed Charles Howes on his way to work. All the while, Jimmy Whittemore's body lay in the dirt by the side of the road, barely visible to passersby.

Within the hour, cranberry picker Samuel G. Merchant of South Dennis was driving a load of cranberry harvesters through the narrow road when suddenly George Nickerson, riding next to Merchant, spied the body and cried out, "There is a body of a man in the road, right ahead. Stop the horse! Quick!"

The dead man was identified as Jimmy Whittemore.

That very moment Idella, beside herself with worry, had traced Jimmy's route through the South Yarmouth woods. As she came upon the crowd of men on the wooded road, she was recognized by one of the cranberry pickers who surrounded the body.

"They were loathe to break the fearful news to her; still it had to be done," wrote Donald Trayser in "The Bakery Boy Murder," a short account of the Whittemore slaying in the August 1968 edition of the *Cape Codder*. "Leaping from the wagon," Trayser continued, "she ran to the spot and flung herself on her son's body."

Word of the killing spread through Yarmouth and Dennis faster than a barn fire in July. Authorities arrived at the scene. In the hour following the discovery of young Whittemore's body, local police sealed off the area and began to look for clues that could lead them to the killer. The area where Whittemore died was on a knoll locals would later call Murder Hill, now Station Avenue in front of Dennis Yarmouth Regional High School in South Yarmouth.

Gruesome details emerged. One police official told a reporter from the *Boston Daily Globe* that the position of the body made it clear that the "body was pulled out the side door of the wagon, right between the wheel…[then] the body was robbed, doubtless of a large bag of money, and the wagon driven on, the hind wheel being driven across the victim's chest, as the track and impression of the wheel was very plain."

Wheel marks from the wagon indicated that the wagon had first been turned into the road, and then stopped for several moments, as evidenced by the numerous impressions of the horse hooves as though the horse had moved back and forth several times, and by the crossing and recrossing of the wheel marks. Whittemore's cap, clotted with dust and blood, was found ten feet from the body. The bag of money, holding at least twenty-five dollars, was missing.

At first, many suspected a band of burglars from Bourne of having killed young Whittemore. Then, some folks began to recount having seen another

young man wearing a checkered suit riding in the bakery cart with Jimmy the previous afternoon. It was a matter of time before witnesses' stories began to match up.

The last person seen with Jimmy Whittemore was none other than Edwin Ray Snow. Moreover, Snow had hurriedly left town on the morning train to Middleboro.

While local reporters and journalists from Boston interviewed those closest to the victim and the suspect, police moved to the next phase in their investigation. State Detective Simeon Letteney of Hyannis and his assistant, Sheriff Judah Chase of Hyannis, headed the team. Naturally, Snow had become an instant suspect the moment his name was mentioned in connection with Whittemore's last hours.

Letteney had investigated Snow in his prior scrapes with the law, and vowed to track Eddie to wherever he had fled. Letteney and Chase went to the Snow home but found no one there. By this time, Eddie Ray had boarded the train for Middleboro, and the detective and the sheriff, in hot pursuit, boarded the next train there. When they arrived, they learned that Eddie had borrowed a bicycle and was last seen headed for Taunton. Investigators confirmed that Snow had changed the silver coins from Jimmy's bag into bills.

Adding a touch of comedic relief to the pursuit, Letteney and Chase boarded a carriage to take them to Taunton, but en route who should they encounter but Edwin himself, pedaling for all his might back to Middleboro. Letteney instantly ordered the carriage turned around, and the proverbial chase was on.

Snow was said to have led them on a "lively race" until all reached Middleboro Four Corners. When they arrived, Snow attempted to elude his pursuers by riding the bicycle between two buildings. When that failed, he abandoned the bicycle and ran. Letteney proved more agile. He caught up with Snow, grabbed him by the shoulders and would not let go. "I want you!" he was reported to have shouted at Edwin.

Their quarry cornered, Letteney and Chase discovered Snow in possession of the amount of cash money Jimmy had been carrying.

Less than twenty-four hours following the murder of Jimmy Whittemore, Edwin Ray Snow was in custody as the chief suspect in the killing and on his way to the Barnstable County lockup, closely guarded by Detective Letteney and Sheriff Chase. Few details of his arrest survive. The exception is one odd anecdote during his first night in jail. Snow was reported to have sung loudly and recited Bible verses. His behavior confirmed what most neighbors had always thought: not only was Eddie a troublemaker, but he was also crazy.

Snow was arraigned the next day, September 15, 1899, in Barnstable Superior Court for murder in the first degree of James T. Whittemore. Thomas Day of

Barnstable was secured as Snow's defense counsel with Raymond Hopkins as assistant counsel. Snow pleaded guilty at first, and then changed his plea to not guilty. On the same day, Mrs. Snow returned to Yarmouth Port from vacation in New Hampshire, unaware that her son had been arrested for murder. Albert Snow had remained in New Hampshire to fish.

Meanwhile, the bereaved Idella Whittemore arranged to bury her son. His funeral was held on Saturday, September 16, followed by a burial in the South Dennis Cemetery. Results of an autopsy performed on Jimmy's body by Barnstable County Medical Examiner Dr. G.N. Munsell of Harwich were given to the *Register*, and revealed that Whittemore's death had been caused by a "ball from a .32 caliber revolver entered behind the right ear, passed through the brain, coming out the right eye, death being instantaneous."

Jimmy had a watch in his pocket and wore a ring "belonging to a South Dennis girl" on the little finger of his left hand, the newspaper reported. To this day, the identity of Jimmy's sweetheart is unknown.

Jimmy's murder stunned and enraged the townsfolk of Dennis and Yarmouth, indeed, all of Cape Cod. Charles Swift, the powerful and opinionated editor of the *Register*, assumed the role of the official voice for many Cape Codders who sought to understand the savage nature of young Snow, a killer who had been taken into the community as one of their own and lived among them most of his life.

"As to the young Snow," wrote Swift, "he was picked up in the streets of Boston near the Record office, and brought to this place as the beneficiary of a charitable society in that city." In a subsequent editorial, Swift continued to imply that the "bad blood" of Snow's mysterious natural parents was at the root of his evil. Was this an absolution of Albert and Ida Snow? "Not a single one of the perpetrators of recent murders, arson or robberies which have occurred on the Cape, who is known as such, is of native Cape Cod origin."

Public sympathy for the widow Whittemore was very much in evidence. By October, the *Register* had set up a charitable fund for Idella and received donations of one and two dollars apiece from friends and neighbors. Surprisingly, Christian support was also extended to Albert and Ida Snow, who were not blamed for the evildoings of their adopted son.

For Albert and Ida, the anguish and shame of Edwin's crime were as painful as Idella's mourning. The family that had raised Edwin Ray Snow now held him at arm's length. It was clear to his brokenhearted parents that Edwin's future was in shreds. To show the depths of his condemnation, Albert Snow revised his last will and testament to disinherit Edwin Ray and his heirs. "I purposely made no bequest in this will to my only living child, Edwin R. Snow, and I exclude him and his issue, provided he die before me, from any claim upon my estate of every nature and description," the document read.

The past blights on Edwin's record—the breaking and entering, larceny, even the stint at Concord Reformatory—now seemed as significant as spit. This time, there existed no way out for Edwin. Nothing could erase the taking of life in the South Yarmouth woods.

On January 2, 1900, a sullen Edwin Ray Snow stood in Barnstable Superior Court to answer to a charge of first-degree murder.

Inside the courtroom, the Whittemore clan and Albert and Ida Snow gathered for the arraignment. According to Donald Trayser, Edwin appeared in court with "hands in his pocket, stood gazing coolly around the room during the reading of the complaint."

Shortly after noon, Edwin pleaded guilty to a charge of murder in the first degree. There was, in fact, no trial, and subsequently, no jury. The entire proceedings took only twenty minutes. "The sensational denouement was a complete surprise to everyone except the counsel of young Snow, and is the sole topic of discussion from one end of the Cape to the other," the *Daily Globe* reported. "Snow's case had attracted widespread attention on the Cape, being the first murder trial in the county for 20 years," the paper claimed.

The principal investigators of the case were stunned. Sheriff Chase had summoned one hundred jurors for an upcoming trial, and had seen to it that all were to be comfortably accommodated. The prosecution had prepared nearly one hundred witnesses, and it was expected that the trial would take at least a month.

"This morning proceedings were expected to be nothing more than a perfunctory request for a delay of one week in the opening of the trial," the *Boston Daily Globe* explained. "It being understood that there would be no objections to this arrangement, not more than a half dozen persons, save the sheriffs and court officers, were present."

Judge John A. Aiken, who was to preside over Snow's trial, arrived from Boston on the morning train on January 2, 1900. With him were Attorney General Knowlton and, from New Bedford, District Attorney Holmes. Just after their arrival, they met for over an hour with Edwin's two lawyers, Thomas Day of Barnstable and his junior counsel, Raymond Hopkins. A deal for Snow to plead guilty and be sentenced to die was agreed upon. Then Governor Murray Crane would commute Snow's sentence to life in prison.

Of course, no one other than Hopkins, Day, Holmes, Aiken and Knowlton knew of the plan. It was anyone's guess what was going on behind closed doors. "No one thought that Snow would stand up and in an absolutely indifferent manner, confess that he killed James Whittemore," reported the *Boston Daily Globe*. "Snow's counsel had hoped for nothing more than to save their client from the electric chair, and they used every endeavor to have the prosecution agree to accept a plea of murder in the second degree," wrote a *Globe* reporter. "This they could not do, however, and their only hope was the promise of

Attorney General Knowlton to intercede with Gov. Crane for a commutation of sentence."

When their meeting ended, Counselors Day and Hopkins met with Edwin and persuaded Snow to plead guilty to first-degree murder. Hopkins said something to Edwin that planted a seed in Snow's mind. Perhaps to persuade Snow to accept the terms, Hopkins told Edwin that one day he might be freed, maybe in twelve to fifteen years. Edwin would cling to that promise for decades.

Judge Aiken sentenced Snow to die in the electric chair on March 18, 1900, "at an hour between midnight and sunrise of such day you shall suffer the punishments…and may God in his infinite goodness have mercy upon your soul." Until the execution, Snow was to be incarcerated at Charlestown State Prison in Boston.

As he boarded the train to Boston accompanied by the law enforcement officers, Snow was allowed to speak to reporters. His statement was published in the *Register* a few days later:

> *I killed Jimmy Whittemore, a dear and good friend to me, on the impulse of the moment. I had no intention of committing such an act when I went to ride with him on that fateful day in September last. We rode together while he [was] peddling, and we were at a point in the South Yarmouth woods when without a moment's meditation I pulled out my revolver and shot Jimmy. I fired one shot and in an instant I fired another. Jimmy Whittemore was dead before the second shot. I wish you could correct the report which had been circulated that I shot young Whittemore a second time while he was sitting by the road. That is not so. He was killed instantly by the first shot, and why I fired the second or even the first, is more than I can tell. Please say for me that I did not plan to kill Whittemore. It was done on the impulse of the moment and God only knows why.*

There are glaring inconsistencies in this public statement. For example, Snow was quoted as referring to Whittemore as his "good friend" but the truth is that Snow barely knew Jimmy even though they were distantly related. "He was not my chum, or even schoolmate, but a resident of another village," Snow wrote in an unpublished memoir some thirty years after the murder, a memoir in which he never mentioned the public statement attributed to him by the *Register*. It is difficult for the modern reader to determine which of Snow's contradictory statements was true. Perhaps the truth lies somewhere in between. We will never know, for Edwin Ray Snow had been an accomplished liar before becoming a murderer.

4

INMATE #12,673

Charlestown State Prison, completed in 1805 to keep its inmates apart from society, was a bleak brick fortress when Edwin Ray Snow arrived in the dead of winter in January 1900.

Massachusetts was the first state to build a prison that was separate from a county jail. The Commonwealth's first attempt at a penitentiary was on Castle Island in Boston Harbor, which opened in 1785. Architects of the day felt that the island setting would thwart escape. Unfortunately, for prison officials, more than a few inmates were able to swim to freedom from their island-bound prison. In 1803, the Massachusetts General Court passed an act approving the construction of a new facility. When completed, the State Prison at Boston, also known as Charlestown State Prison, was two hundred feet long and forty-four feet wide. The prison was located between Washington and Austin Streets, near the Boston and Maine Railroad tracks that intersected with the Eastern Freight Railroad, according to a map at the Massachusetts Archives. (It is now the site of Bunker Hill Community College.)

Construction of a north wing was underway by 1828. The south wing was built in 1850. Over the years the prison grew. By 1867, the guardroom was converted into 100 additional cells. By May 1878, many prisoners at Charlestown were transferred to a new state prison at Concord. The old prison refilled. Another wing constructed at Charlestown in 1886, the west wing, added nearly 60 cells. By the early 1900s, according to records at Boston Public Library, Charlestown contained 850 prison cells.

By September 1903, 75 prisoners at Charlestown State Prison were serving life prison terms, another 54 had varying terms to serve and 863 men were being held under maximum and minimum forms of sentences, according to the laws of the time. Charlestown State Prison would remain an active penal site in Massachusetts until November 1955, when the infamous but antiquated institution closed its doors. Inmates were shuttled to other prisons.

But the Charlestown State Prison that greeted Edwin Ray Snow some fifty-five years earlier was considered adequate for a convicted killer.

Snow was one of the youngest prisoners ever at Charlestown State Prison. The other nineteen men entering Charlestown State Prison in mid-January 1900 were convicted of crimes that included incest, arson, burglary and robbery. Among them were fifty-nine-year-old Thomas F. Baker of New Hampshire, convicted of rape, and Daniel J. Lynch, twenty-seven, who would serve four years for "maiming."

Edward Ray Snow thus became Prisoner #12673. Several days after arriving at Charlestown State Prison, Snow was informed that his death sentence was commuted to life in prison by newly elected Massachusetts Governor Murray Crane. The commutation was the result of agreements arrived at between Governor Crane's representative, Edwin's attorneys and the district attorney: his life would be spared if he spent the rest of his life in prison.

As Prisoner #12673, Edwin Ray Snow was told when to eat, where to eat, when to sleep, what to wear and when to work. Many years later, in his unpublished autobiography, Snow remembered those miserable weeks and months at Charlestown State Prison. "In room, shop and elsewhere there was a silent system. One hour, once a week, in the yard. No communication by speech, association or writing. It was a long grind, room [cell] to shop, shop to room not athletics, no games, no music, no amusements, no visits. A still situation for a boy 17 years of age."

Administrators at Charlestown put Edwin, a healthy young man, to work immediately. For many years Massachusetts prisons "derived great income from its prisons' laborers for public use," according to one state annual report from the turn of the century. Monies generated from the sale of manufactured goods sold to sixty-six public institutions scattered throughout Massachusetts covered the cost of running the prisons. Snow's first stint at hard labor was in the prison harness factory "till I learned the whole trade," according to his memoir. "We worked from bell to bell on a special hand-tooled coupe harness."

The early months at Charlestown passed quickly. Nearly a year after he killed Jimmy Whittemore, Edwin Snow appeared to have settled into prison life with an established routine at Charlestown State Prison. In September 1900, Snow began "teaching school" via a correspondence course offered by the prison to other inmates. A check through existing prison records reveals nothing about such a program, so we are left with Snow's word and memories. If he is to be believed, he taught English, arithmetic, algebra, French, bookkeeping and Spanish from 1900, the year the correspondence school was alleged by Snow to have started, to 1912. Snow claimed that the "class size" ranged from ten to twenty men, "all done by correspondence, and pupil and teacher unknown to each other."

During these early years, Snow found another interest to occupy his time: religion. Like so many convicted criminals, then and now, who have claimed to be saved by Jesus Christ, Snow found salvation in prison. "In 1903 I was confirmed in the Episcopal Church," wrote Snow, who grew up in a strict Baptist household. Edwin took communion once a month. "At that time it was a means that kept many a man from insanity," Snow wrote in his memoir.

It was in prison that Snow learned compliance and duty. Snow held various jobs during his incarceration. These jobs engaged his mind with activity and equipped him with a strong work ethic and a discipline that had evaded him in his youth. Always an avid reader, Edwin had the time to consume words and nourish his appetite for general information on all subjects when he wasn't working in prison industries.

The years passed. In March 1905, Snow turned twenty-two years old. Many of his peers back home in Yarmouth were beginning careers, getting married, raising families or at university. The imprisoned Edwin was assigned to rough outdoor labor in 1905. A year later, Snow was back in the Harness Department as a saddle maker. By the time he turned twenty-six, Snow became a pattern maker and cutter for the new Mattress Department. Edwin stayed in that industry for only a year. Nearing his late twenties, Snow worked at classifying fifteen thousand books in the prison library "to conform to the new Dewey System," he wrote years later.

In 1912 Snow, according to his memoir, worked in the prison luggage factory making bags and suitcases and other hand-sewn specialty items. Also in 1912 Snow stopped teaching in the correspondence program to take over the harness shop. From 1903 to 1923, Edwin used his off-hours to make "belts, purses, travel bags and brief cases. Never had to ask anyone for a dollar," Snow remembered.

Working with leather would be a skill that would serve Snow very well in his later years. As he neared thirty, Snow had become somewhat of an expert in the field. He claimed that for a year, 1913 through 1914, he instructed other prisoners in the art of leather craft. He might have dreamed of life on the outside just as Cape Codders' thought of his freedom would awaken in them a nightmare.

5

CHARLESTOWN STATE PRISON, 1900–1914

In January 1912, almost twelve years to the day after Snow was shackled and sent to Charlestown State Prison, Edwin was introduced to a man who would change his life. Reverend Spence Burton was a young, American-born Anglican priest on staff at the Church of St. John the Evangelist whose Anglican mission house at 33 Bowdoin Street in Boston's West End was up and running when he first met Snow, and is still used today. (The brothers still operate a monastery on Memorial Drive in Cambridge.)

Father Burton, Snow's senior by a few years, was from a distinctly different background than Snow. Spence Burton had led a privileged life in the Midwest. He had been born in Cincinnati, Ohio, on October 4, 1881, son of Casper Henry Burton and his Detroit-born mother, Byrd Waithman Spence, for whom he was named. His wealthy parents provided Spence with opportunities to which affluent children grow quickly accustomed. Young Spence attended elementary and secondary schools, and then came to Cambridge for a college career at Harvard College, where he received his bachelor of arts degree in 1903 and masters of arts in 1904.

During his undergraduate days, young Burton began attending services at the nearby Church of Saint John the Evangelist, becoming acquainted with the Crowley Fathers, whose organization was founded in 1866 in Oxford, England. When he left Harvard, Spence Burton spent two years at the General Theological Seminary in New York City. He returned to Boston in 1907 and became a postulant in the Society of St. John the Evangelist. In 1908, Burton was ordained and left the states for Oxford, England, to study with the Crowley Fathers. Four years later, Burton returned to Boston in 1912 to work at St. John's mission house at 33 Bowdoin Street.

Father Burton worked closely among the inmates at Charlestown State Prison, including Edwin Ray Snow. We may safely assume that as one of the

few "lifers" at Charlestown State Prison, it would have been natural for Father Burton to have met Edwin and minister to him.

Edwin, at thirty-one, applied for parole in May 1914. This plea for freedom was a bold step for Snow. Edwin had only served fourteen years of the sentence many on Cape Cod believed would stretch to the very last of his days.

Edwin's official plea came before a three-member Advisory Board of Pardons. "We have no power to pardon," a spokesman said in 1914, adding, "we simply will hear a statement and report to the Governor our recommendation." Only Governor David Walsh had the power to set Edwin free. Edwin Ray Snow was permitted to speak on his own behalf during the hearing held in May 1914. We can only guess what was going through his mind when he applied for pardon. Could he have honestly hoped to go free after serving only fourteen years? It may be that the 1914 request arose from Snow's self-confidence. Whatever his thinking in spring 1914, Edwin wanted to appear his best at his hearing. Unfortunately, Edwin became sick on the day of the hearing and was confined to the infirmary until his appearance before the board.

The prison medical director, Dr. McLaughlin, spoke in Snow's stead, and told the panel that Edwin Snow was quite ill. "He is in rather poor physical condition just at present due in great part to worrying over his sentence and the prospects of a favorable or unfavorable hearing before the parole board," said Dr. McLaughlin. "He has been unable to sleep more than two or three hours a night for some time until recently, when I admitted him to the hospital," the doctor added.

The Advisory Board of Pardons allowed Snow abundant opportunity to air his views, which Snow took advantage of to reiterate what he considered his stellar record.

> *The second year that I came here I started in the correspondence school, they established a school here in 1902, there were a few of us banded together, about then as I remember—we wanted to see what we could do…for the men in here—I have put in twelve years at teaching—I have taught grammar—I have taught algebra—I have taught geometry—I have taught arithmetic—I kept at it for twelve years—I worked hard all day in the shop.*
>
> *I went into my room and worked there until the lights went out in order to provide the little toilet necessities that are not free here—Sunday I gave up to correcting these lessons—I kept that up for twelve years—I had to give it up. Two years ago the superintendent of the harness shop resigned and I was called upon by the deputy to place and instruct the men—for two years I have done that—it is a job on the outside I would command fifteen hundred dollars a year.*

Based on his statement traced through transcripts at the Massachusetts Archives, Snow appeared to have rambled on about his upbringing at the hearing. Edwin had an intimate friendship with bad judgment. "I started to go to high school," Snow told the board, "then I got to reading bad novels that had a detrimental effect. I started going with girls not so good as they could have been." Edwin appeared to be telling the parole board what he thought they wanted to hear. By admitting to youthful misdeeds and showing contrition, and revealing the mature adult he was now, it would appear that Snow thought he stood a good chance at parole.

In his defense, Edwin claimed years later that he was quite ill during his first pardon hearing. That might explain his apparent incoherent rambling statements to the advisory panel. "I was called here as a patient in the hospital when the testimony was given that day," he would assert years later.

Edwin waited fourteen years to defend himself to people possessing influence to free him. He surely must have taken a deep breath before he dove into his pool of memories to recall the moments of September 13, 1899. Edwin did not begin his recitation on the crime, and it was apparent that mitigating circumstances needed explaining first.

To his credit, Edwin never blamed his misfortunes, missteps and grievous mistakes on his adoptive parents, Albert and Ida Snow. "They sheltered me in every way," Snow recalled, remembering the times his parents sent him off to church and school. "There was a tendency [to shelter me] until I butted my head against the wall," he added.

Edwin admitted knowing little about his biological parents. Speaking of his birth parents, Snow said he was told by the Snows that "this family was related in some ways to the Superintendent of the Poor in the City of Boston, so he shipped me down to this relative of his on the Cape." Edwin had no apparent desires to meet his birth parents. He believed they were responsible for his troubles. "I know whatever my parents were they must have been bad because ever since I was old enough to form any judgment for myself or act for myself in any way there has been that little tendency to do things that I ought not to do, you cannot call it environment, because the environment was the best, I was put into a good family—a religious family," Edwin clarified during the 1914 hearing.

Throughout his life, Snow would insist that a false charge that stemmed from a family feud over an inheritance on his father's side sent him to the Concord Reformatory.

> *There were fifteen children in my* [adoptive] *father's family. My father didn't marry until he was thirty-five. He had taken over the support of his father and mother, the other children were scattered. They had a lawsuit over the property.*

The parents died and willed everything to my father. There was a long drawn-out lawsuit. It cost a great deal of money. It caused a great deal of hatred. The suit was decided in his favor.

This sister had a store right across the street from our house, she had made a threat that some day she would get even for the lawsuit. I was in high school, was to graduate in June, the second in my class.

Life was good for Edwin then. Edwin remembered he and his classmates were studying a play for graduation. "I was walking to school and the state officer for the county, Officer Letteney, said 'I am going to give you a chance to turn state evidence, if you do that you will go free,'" Edwin quoted Letteney. Edwin claimed not to know what the officer was talking about.

He went and got the 9-year-old son of a family who had been on the town [on public assistance] *for a good many years and accused him of being with me, he then got another young fellow and arrested him. He accused us of entering the store of my father's sister. He has as a witness a young boy nine years old—he testified that he broke into the store with us—that he kept watch, that we three went into the store through a coal hole, that was impossible for me to get through because of my size.*

They had to let one of the men go the next day because he proved he was somewhere else, the other fellow could not prove it, so he and I waited trial. The Judge of the Juvenile Court said there wasn't evidence enough to convict—it went to Superior court—up there I was cleared of one charge—there were two cases—the one I was cleared of I knew about.

Snow claimed the breaking and entering charge was "simply a frame-up. My father's sister was taking advantage of the chance to spoil my life by taking me at the only time she could," Snow claimed. "She struck at my parents through me."

During ten months at the Concord Reformatory Edwin displayed severe attention to work given him, and by all accounts responded well to the allocation of duties. "Mr. Batt [apparently a staff member at the Reformatory] heard that I could read Latin—I was clerk for him for two months—then they put me in the library for two months. Officer Jenness took a liking to me," Edwin recalled.

Ten months to the day after Edwin Snow first arrived at Concord, his father Albert went to see Attorney General Knowlton, reportedly to ask for Edwin's freedom. "It was only fifteen minutes from the time they arrived until I was released," Edwin remembered.

Edwin did not stay in Yarmouth long following his release from the Concord Reformatory in the spring of 1899. He headed to Middleboro to live with his

Aunt Nellie for several months, then moved to Taunton into his own place soon after. That September, during a visit to his parents' home in Yarmouth Port, Edwin met up with James T. Whittemore.

"Do you mind stating briefly to the board now the circumstances attendant on the crime, why you did it?" a member of the Advisory Board of Pardons asked Edwin.

"That is a question I have never been able to answer," Snow replied. "There was a gun that belonged to my father—a revolver," Edwin began, explaining how he came to carry the weapon that he used to shoot young Whittemore. "It was at my aunt's house in Middleboro. I was up there—I took it and put it in my pocket," Snow added, explaining that his aunt asked him to do just that since she worried that her young children might find the weapon and think it a toy. Edwin spent the night before the murder in Yarmouth, and testified, "The next day I started back to Middleboro. I went down to my High School teacher, Edward F. Pierce. I asked him for $2.00 to pay for my train fare back to Yarmouth Port. He would not give it to me—he said he had no money about him," Edwin remembered.

Edwin next went to his uncle's house and asked him for a loan. His uncle declined, saying his wife had gone shopping and had taken their cash money with her. As Edwin was leaving his uncle's yard, Jimmy Whittemore came by the house driving a horse-drawn baker's cart. "We took the usual route through the woods," Edwin explained. Snow told young Whittemore of his predicament, to which Jimmy allegedly responded, "Come over and stay with me—tomorrow I will give you the money and you can go back." As he testified before the Advisory Board of Pardons, Edwin's memories appeared to come alive before his eyes. The years melted away and he was seventeen again, sitting beside Jimmy Whittemore in that plodding baker's cart nearing the woods of South Yarmouth, the revolver pressing against his skin through the pocket of his shirt.

"On the way this gun in my pocket," Edwin remembered, "this two dollars stood between me and Jimmy." As would be his lifelong habit, Edwin tried to shift blame onto others for his own sordid actions. "If I had had the two dollars from either my high school teacher or my father's brother I would not have committed the crime," Snow testified.

Moments before Jimmy was shot, as Edwin recalled, "On the way over he happened to turn his head—probably to look at some blazed trees—I simply pulled the gun out and shot him," Edwin admitted. As he would say repeatedly through the years in an effort to explain his role in the shooting, Edwin testified, "There was no reason for it, there is no extenuating circumstances. I have never claimed that because it could not be claimed," he added.

"I can't tell you today why I did it—all the inference that I can draw is that the fast life I had been going and the lack of restraint—being away from home

for the first time and being able to do just as I pleased—it made a muddle of it," Edwin relayed to his audience. "I have thought about it for hours and hours."

There were more questions for Edwin Ray Snow to answer. One panel member wanted to know whether Whittemore "was looking out of the wagon."

"Yes," Edwin replied, adding, "He didn't see the gun taken out and leveled at him."

"Did he fall out of the wagon?"

"No," Edwin answered. "He stiffened up, when he stiffened he went almost to the top of the wagon—I thought he was reaching for me and I fired a second shot. I turned the baker cart into the blind road—my thought was not robbery—he had bills in his coat—he had jewelry and other things—I just took this bag of silver," Snow admitted.

"Did you take the body and put it on the ground?"

"No," Edwin recalled, "his head was hanging out—when I turned the wagon he toppled out. They found him the next morning."

"I threw my gun away in the woods," Edwin insisted. Later he would go back to try to find it. "It took me more than twenty minutes to find it—I didn't know what I was doing. The money I took from him, I changed the silver into bills."

"You had seen him receiving money all day?" Edwin was asked.

"Certainly I had," Snow explained, "he had much more than I took. I didn't go over him at all."

"Had you been drinking?"

"I had been drinking the day before," Edwin admitted.

"How much?"

"Beer—there was a place in Lakeville and a fellow named Loring and myself—I can't remember how much we had," Edwin recalled.

"Had you been drinking several days?" he was asked.

"Yes, I drank because I was sick—I had dysentery the two previous weeks—I drank in place of eating, and I have no excuse," Edwin replied. "I do not pretend to account for it at all, all I know is that I took a life, all I want is a chance to atone for it now."

Edwin pleaded with members of the parole board. He didn't wait to be asked another question before begging, "There is nothing ahead and there is nothing behind. The only atonement that is now is to give my life for others."

For fourteen years, Edwin had lived for this moment. He must have played out the hearing in his mind a thousand times. Now he pleaded for mercy. "I have said everything I can but my salvation rests with you. I think you can estimate my mentality, you know my condition. I have suffered as no man has ever suffered. I would never think of doing anything of that sort again. I have had chance after chance in here to do violence" and have not done so, Edwin asserted.

Edwin told the Advisory Board of Pardons that he was well aware of the negative sentiment of Cape Codders against him, especially Yarmouth residents. Transcripts of the May 1914 proceedings reveal an anxious Edwin Snow relaying information to the pardons board that "the opposition," as he termed those persons against him, had hired a lawyer to fight against his release. "I know a lawyer approached the Whittemore family," Edwin testified, "and they would not discuss the case."

Interestingly, Edwin's mother, Ida Snow, had approached the Whittemore family prior to Snow's parole hearing, probably to secure their forgiveness for her son. The Whittemores were unmoved at the sight of Ida Snow at their door. "They would not let my mother into the house," Edwin sighed. Nor would they admit an attorney hired by "the opposition" who tried to see the family repeatedly. He had been to the house five times before the Whittemores had let him inside. The Whittemores, Edwin claimed, "Would neither oppose the case nor sign a petition" against his release.

Edwin also stated that "the opposition" hired an attorney on behalf of the Whittemore family, who wanted no part of the attorney. "These people of Barnstable County, they thought it was their duty to hire a lawyer for them—they took it on their shoulders to lead the opposition part," Edwin explained. "It hurt me a good deal because I have done everything I could in here to give my life to others. The Deputy can show you that part of it," Edwin added, hoping to enlist as an advocate Deputy Warden Allen.

Having waited so long for a chance to plead for his freedom, Edwin was not going to stop begging for a pardon just yet. "For fifteen years I have given up the opportunity to study for myself," he claimed. "I have not had a chance to study because of the shop work and the other duties I have had," complained Snow. "A few weeks ago—three weeks ago—I had a collapse. I rely on you for some sort of an outlook—to give me some hope I can help myself."

If Edwin is to be believed, his prime concern in May 1914 was two-fold. Naturally he wished for freedom, but he also remained concerned for his aging parents. "My father was taken with his first sickness last year," Edwin explained, referring to Albert C. Snow's bout with rheumatic fever. The sixty-three-year-old carpenter was gradually able to work few if any hours. Albert Snow's workdays as a builder and carpenter had come to a dead end. In an era before social security and other forms of aid to the elderly and infirm, this was a serious matter. "He has nothing laid up" toward retirement, Edwin pleaded.

While concern for his father's health occupied his thoughts, Edwin spoke of his own disability, a hernia, which to him was the end of the world. "So far as this life goes in here I have come to the end. I know I could not last a year longer in here, so if in your judgment there is no way I have to face the inevitable," Snow testified.

Snow said he had been in the hospital for two weeks. The prison doctor would not discharge him "because I am not fit to do anything," claimed Edwin. Edwin feared release from the infirmary, given his constant worries about the hernia flaring up.

"I have simply lost control of my faculties," Snow admitted. He said he used to enjoy reading, but did not any longer. Edwin appeared to accuse the pardons board for giving him little notice of the May 14, 1914 hearing. It is almost as if he were offended to have the hearing while so ill. "I told him when I was taken into the hospital waiting for the hope to see you, I knew my case was turned over on the 12th day of March, since then I have had no news, the next thing I knew you had me up here," Edwin told the parole board.

Edwin spoke very fast; his tone was colored with a pleading resonance, yet it is also clear he tried hard to clutch onto whatever dignity the hearing process left him. "The last two weeks have been very hard, and I know the next two weeks are going to be harder than those gone by," Edwin went on.

In the final moments of the hearing, Edwin spoke of his skills and his usefulness to the other Charlestown State Prison inmates. "Since I have been in here I have worked in five departments in this prison," Edwin began. "I have been cutter in the mattress shop, I have been runner in the carpenter shop, I have been in the library fourteen months, and I have been out in the yard." Snow claimed that he had been in contact with more men than any other Charlestown inmate. "I would be willing," Edwin offered, "to pass the knowledge that I have right along, I know their standards of living, I know their points of view, I know their ambitions, if they have any. I also know their warped judgments," Edwin said, adding, "I do not think that there is anybody in this state today that could do more good for the men that are in here than I could do." Snow said he had thought about the other men a great deal, but it is unclear what his intentions were regarding the status of other prisoners. Did Snow wish for a job as an inmate advocate? Or did he wish to teach the inmates, share his knowledge with them?

In the early portion of the hearing, Snow was asked why he had applied for clemency after only fourteen years in prison. Snow responded that Assistant Counsel Raymond Hopkins had allegedly told him in January 1900, just before his appearance in Barnstable Superior Court, that "in twelve to fifteen years you will have a chance to get out."

Can you picture Edwin Ray Snow, year after year, biding his time until that intangible deadline had passed? In addition, if Hopkins had really said that, was it uttered merely to persuade Snow to plead guilty all those years ago? One Cape Codder who fought against Snow's release was State Police Officer Ernest Bradford. Without hesitation, Bradford, through a written statement, recounted for the parole board the night of September 13, 1899. The state

police officer claimed that the Snow home was searched before he was arrested. There officers found "a sink containing water and a wash basin." A chemist, Dr. Wood, analyzed the water and found "blood corpuscles." Snow would later admit to police that he went home and washed his hands after shooting Whittemore. Then he changed his clothes, got his supper and went right to bed at the Bassetts' home across the street. Years later, Snow said he placed the revolver he used to shoot Whittemore back in his parents' house.

Bradford, one of the original police officers on the case, provided a bizarre account of the murder and the flurry of activity that ensued once Jimmy's body was discovered. His testimony contradicted published newspaper accounts and Edwin's own memories of the day, and carried unsupported and spurious insinuations about Edwin's mother.

After the murder, Bradford wrote to the board of pardons, "In the vicinity of 9:00 Whittemore's team was found wandering in the streets of Yarmouth without a driver. A man named McCarthy picked up the team and he found a bullet in the wagon." Official reports indicated that Eben Hamblin found the team and that he detected blood, not a bullet.

Bradford claimed "police got to the wagon around midnight. We brought the wagon to Hyannis. We started out to search about 5:00 in the morning." Bradford's account clearly challenged all other timetables on the case. However, the rest of his remarks confirmed, more or less, the public account of events. At one point in his letter to the board Bradford claimed that during the search for Snow police learned that "he had a girl in trouble in Lakeville." Nevertheless, Bradford offered no evidence to establish that Edwin had fathered a child, and any other law enforcement officer did not mention the possibility. In another wild accusation, Bradford claimed "it was reported by Snow's attorney at the trial that Mrs. Snow is his mother and that she gave birth to him before she married Mr. Snow. He was taken care of by Mrs. Snow's mother, old Mrs. Huckins, and after her daughter Ida married Albert the boy was legally adopted by him." Snow had no trial in 1900, and it is not clear from where Bradford's proof came.

Edwin's adoption records do not offer any useful information. In 1946, the Department of Corrections requested them from the Barnstable County Register. When they were released, all the record declared was "that he was a child of unknown parentage and that he was born in some unknown place on or about March 10, 1882; that he was committed to the care of the State in his infancy; and has since been supported at the expense of the Commonwealth."

The Advisory Board of Pardons also heard from Deputy Warden Allen. "I don't know that I have anything to say," he told the panel. "He has his peculiarities," Allen added.

That last statement proved harmful to Snow. Oddities—mental quirks—were treated in 1914 as almost criminal. Surely, that consideration would play into the board's upcoming decision.

Snow had told the board that he was entrusted with inmates' monies and carried other responsibilities at Charlestown. Deputy Warden Allen disagreed, suggesting that Snow exaggerated his responsibilities when asked if Snow had been in charge of one of the industrial shops. "Hardly to that extent," Allen replied, "so far as we can trust any prisoner but always under the eye of the superintendent." If Edwin Ray Snow had exaggerated his role as trustworthy inmate, the advisory board would surely have noted it in any recommendations concerning his freedom.

Edwin also had to contend with the damaging testimony of Dr. McLaughlin. "I believe that he is in a way a moral pervert," the physician told the parole board. "Besides that a sexual pervert." In his statement, the physician was referring to a homosexual act between Snow and another inmate.

Naturally, Snow was questioned by the board. "Do you find you have any irresistible impulses at the present time?"

"The unnatural act was a product of what is in here—that is one of the most common things in here," Snow responded, alluding to the common occurrence of homosexual activity at Charlestown Prison.

Many years later Snow would write about the incident that led to what he termed "the one punishment," in 1907:

> *I permitted a young Cuban to perform an act of impurity on my body. I have never seen the thing done. I did not know he was a professional pervert. I was a young, hot-blooded, ignorant kid, and the marching formations at the time compelled me to rub against him, sit beside him, several times a day. This proximity, the constant talk about such matters, the over-emphasis on religion, aroused a curious mental and emotional state that was stronger than natural instincts and aversions, in a situation devoid of normal expressions.*

Shame and regret were only the beginnings of the humiliation Snow was to endure in 1907 for a moment of guilty experimentation and pleasure. "The Catholic priest stood in the chapel and ordered the inmate body to shun me. The Episcopal priest refused to let me attend his service. The Warden dropped me from the school list. My parents turned aside. Just one human staid [*sic*] my friend," Edwin recalled. Snow didn't say who that friend was. "This was my initiation into the ways of men when a fellow gets in a jam. I will not recount the surprising, bitter beating back," he would write years later.

For a long time Edwin stewed about an apparent early release given the Cuban. "The man who committed the unnatural act was held only twenty-

two days at the end of his sentence. He could have been given an additional sentence, but for eight years the warden had given him special treatment," Edwin wrote.

Still the homosexual encounter, however brief, was one that filled Snow with deep regret, remorse and self-revulsion. "I paid with my life blood, for twenty-two years, for this indiscretion," Snow recalled. Snow became an outcast in the prison community. He lived as a pariah in a community setting, even if that setting was one where everyone was punished for something.

Less than a year after the "unnatural act," Snow got himself "in a new room, reinstated in the school without the privilege of having my name made public, but doing the teaching privately and reinstated in September to do the teaching, but not being placed on the public list of teachers and was reinstated in the Episcopal service before the first year had expired after my act," Snow wrote in a memoir many years later.

He sounded angry that while his privileges were restored they were not publicly acknowledged as having been. Evidently, what other prisoners thought of Snow, and his "social position" in the prison community, mattered to him.

Edwin Ray Snow's parole request was denied. "The Board feels that Snow is an excitable, unbalanced man, lacking in self control; a man unfit for freedom," so stated the report to Governor David I. Walsh in a letter dated July 17, 1914. Cited as a major reason for denying parole, "Snow has been punished in the prison for committing an unnatural act with another prisoner."

While the board acknowledged Snow's youth at the time of the Whittemore killing, there was, the board wrote in 1914, "no shadow of excuse or extenuation for the crime, which seems to have been the culmination of a misspent, though youth-ful career." In other words, had Whittemore's killing been in self-defense or an accident, the board might have felt legal mercy toward Snow. The nature of his crime, along with his getting into trouble in prison—the Cuban indiscretion—spelled doom for Snow.

Edwin Ray Snow would not see the light of day outside of Charlestown State Prison any time soon. He went back to his prison routine at Charlestown's leather factory. "I was an instructor," Edwin later wrote. "I gave out materials and showed men how to cut patterns and make articles."

He gave up the idea of applying for a pardon, for a while.

6

SEEKING FREEDOM
AND FORGIVENESS

I f Edwin Ray Snow was nothing else, he was persistent. If he hungered for freedom in 1914, by 1917 he was ravenous for liberty, when once more he applied for clemency. If granted freedom, Snow knew he was young enough to start over somewhere else. Even marry. Start a family.

Once more, his case came up before the governor's Advisory Board of Pardons. A hearing date of October 17, 1917, was set. This time around, Snow prepared for the proceedings, and took valuable experience from the hearing of 1914. For the first time, Snow hired a lawyer. His defense counsel was Alvin H. Bacon, a Boston attorney. Several family members and friends prepared to speak in his defense.

However, Edwin Ray Snow did not count on the long memories and renewed tenacity of Cape Codders, especially Yarmouth residents, who would not forgive "that awful cold-blooded murder of Jimmy Whittemore." A committee of prominent Cape residents formed and traveled to Boston to speak against any consideration the Advisory Board of Pardons might be inclined to grant Snow. Hyannis attorney John D.W. Bodfish, a blind but able barrister, represented Cape Cod residents.

During the pardon hearing, Bodfish testified that people on the Cape felt Snow was "abnormal," and that no terms of release were acceptable. When asked, however, Bodfish also admitted that he had never actually met Edwin Ray Snow. In fact, the first time Bodfish and Snow had come face to face was the day before.

It remains unclear who initiated a meeting between Snow and Bodfish, and why. However, it appeared that after meeting Edwin, Counselor Bodfish had a drastic change of heart where Snow's life sentence was concerned. Bodfish made an astonishing statement at the parole hearing, which no doubt surprised and infuriated friends back home. "I believe the people of our district would be willing to have him out," Bodfish told the board.

A ghost from Edwin Ray Snow's past was next to testify at his 1917 pardon hearing. The mere sight of Elsie Fox Goodrich, a former sweetheart, must have been heartwarming but bittersweet for Edwin. Elsie, who had traveled to Boston from her home in Lakeville, talked about the last time she had seen Edwin. It was the morning of September 12, 1899, a day before the murder. "He acted the same," Elsie recounted, remembering perhaps Edwin's self-described happy-go-lucky days when he was more concerned with frequenting youthful haunts and buying ice cream than paying his aunt for room and board.

Elsie, under delicate questioning, denied ever "getting into trouble" with Edwin. There was little else Elsie could add, other than that she had enjoyed Edwin's company when the two were younger. Elsie had moved on long ago, marrying in 1902. Still, it was brave for Elsie to travel to Boston to testify on behalf of a convicted killer. By 1917, Elsie was close to middle age and the mother of two children.

Another woman entered the hearing room once Elsie left. We cannot be sure if Edwin was in that hearing room or not. Existing records do not say. When Eloise Doherty walked into the room, might Edwin have glimpsed what freedom could have held for him: the love of a woman, a sturdy hearth, steady employment and children?

Eloise and Edwin had first met as children. They had played together, as the Doherty family lived close to Edwin's beloved Aunt Nellie. Edwin had worked for Eloise's father, a printer's foreman at H.L. Thatcher and Company, during his post–reformatory days in Middleboro, that small stretch of time before he shot and killed Jimmy Whittemore.

"I consider that he would be a perfectly safe man at large," Eloise confidently relayed to the pardons board. Eloise had not deserted Edwin Ray Snow during his years at Charlestown. She had visited him no fewer than a dozen times since his incarceration in 1900.

Edwin's adoptive father was next to testify, according to scant records on the proceedings available through the Massachusetts Archives. In 1917, Albert C. Snow was not a well man. "I have been ill for four years," the aging carpenter told the parole board. "I had a severe attack of neuritis. I have to wear flannels," he confided.

Clearly, the years had not been kind to Albert. Though Albert and Ida Snow were held in the highest esteem in Yarmouth despite the deeds of Edwin, being well regarded does not provide ample income, nor does it ease the fears of growing old. Sadly, their two infant daughters had been buried long ago, and their incarcerated and only son, who according to tradition might have looked after them, was no help. As Albert aged, it proved trying to earn enough as a carpenter and builder, a physically demanding job, to support himself and his wife. "I am getting old now that I cannot do what I could do twenty-five years ago," he said.

Seeking Freedom and Forgiveness

Without seeing Albert Snow's face or hearing his voice, one can imagine his worry and fatigue. Still, Albert came to Charlestown at least twice a year to visit with Edwin. "It is a very long way to come and we do not get up here very often," he told Frank Brooks and the others.

Albert faced the pardon board with all these sorrows on his weary shoulders. The elder Snow recounted Edwin's youth, and wondered aloud where his son had taken a wrong turn. "He had been reading novels and I think it did not have a very good impression on him," Albert remembered, and added, "He got carried away with them."

Even when Edwin returned to the Snows from the Concord Reformatory, Albert Snow remembered seeing damaging changes in Edwin. "He wanted to go out with the boys all the time and I told him he could not go," Albert told the board. His wife then testified.

During his teen years, Edwin's parents often let him stay with Nellie and Hiram of Middleboro. Later, Ida and Albert questioned the supervision given their only son. "She would let him go out nights in the streets and perhaps he got into bad company," Ida testified. "At home we knew where he was every night. He attended public school and was about to graduate high school when [the murder] happened."

Ida Snow remembered seeing Edwin about a week to ten days before the Whittemore slaying. Ida and Albert prepared to vacation in Glendale, New Hampshire. It was rare for the Snows to get away from the Cape and relax. Edwin had been ill, and Ida offered to cancel her trip to the Granite State. Edwin would have no part of it. "Mother, I want you to go away," Ida remembered Edwin telling her. "I will be all right," he said. Someone on the pardons board had evidently questioned Mrs. Snow about Edwin's tendencies, if any, of cruelty toward animals. In May 1914, the prison doctor, who referred to Edwin as a "moral pervert," called Edwin's mental status into question. Given the time, 1917, it was common thinking that if someone could harm animals, humans would be next.

"Did you notice anything in the treatment of dumb animals?" Ida was asked.

"He loved our parrot," Ida fondly remembered. "She calls his name to this day…we had a pet cat. He never troubled her in any way." Ida paused for a moment. She looked squarely at the parole board and in her quiet manner said the killing came as a "great shock" to her.

After Albert and Ida Snow testified on behalf of their son, Idella Whittemore appeared. She was a woman known throughout Cape Cod, an object of both pity and admiration. Idella had become acquainted with Albert and Ida Snow, the State Police Detective Ernest Bradford, as well as several judges, ministers and well-intentioned people in Dennis, in particular her village of South Dennis. Mrs. Idella Whittemore sat in front of the parole board. It took great

effort for her to attend the parole hearing of the man who had gunned down her second-eldest son. The trip by rail was tiring and long for a woman her age. To be near the man who murdered her son was sorrowful. Idella Whittemore, however, was a good Christian woman.

Her words must have melted the heart of Edwin's elderly mother, Ida. "It is well enough to give him a chance [for freedom]" Idella said. Mrs. Whittemore had come to Boston at the behest of Edwin, who had written her repeatedly, seeking forgiveness and asking for a meeting. After consulting with her minister, Mrs. Whittemore decided it was high time to meet her son's killer. There remains no doubt the move was a mighty one, and brave, for Idella Whittemore to make. At the time of the murder, Idella told the parole board, she had six little ones at home. Her husband, James A. Whittemore, had been dead less than a year. Jimmy had been the sole source of support for his mother and younger siblings.

Edwin Ray Snow, Mrs. Whittemore testified, was a young man she had hardly known. After all, the Snows lived in Yarmouth Port, six miles from South Dennis. With the residents of villages being independent, their paths rarely crossed. "I saw him once," she remembered. Mrs. Whittemore said that she would not describe herself as a vengeful woman. "I do as I would want someone to do by me," she explained. Clearly, Idella pitied Albert and Ida Snow. "They are nice people," she said of the Snows. "They live quite a way from me. I can get on the train and get there quickly, though." (Whether Idella meant to Yarmouth or the Snow home is unclear.)

Idella talked about how hard her life had been since Jimmy died. "Money is hard to come by," Idella admitted. "I had one son who lived with me and he is married and now I am left alone. Of course folks say 'you have got children, go live with them.'" Idella wished to live alone, though. She took an occasional meal with her children, and said, "I have got to have some help from someone for some other things." Idella's children were all working to help support her, but times were difficult for their families too.

Had he lived to 1917, Jimmy Whittemore would have been thirty-eight years old. He might have married, had a family of his own, been a further help to his mother, who had been living in near poverty since the death of her husband.

Her married daughter, Sarah Whittemore Small, had accompanied Idella Whittemore to Boston. Sarah, the young lady voted "most handsome" at a Fourth of July fair held in Dennis in 1899, echoed her mother's Christian sentiments toward Edwin when she testified, "If he has a chance he will make a good citizen."

Edwin testified next and was immediately questioned about the murder. Snow reiterated his testimony of 1914 with few notable additions. The day before the murder Edwin had visited his friend, Eloise Doherty. It was a social

call Edwin's friend wished he had not made. Snow had eaten so much fruit and got sick, he said, with dysentery. "I went up to a friend's house and she said she did not want me sick on her hands and I took a train home about four o'clock," Edwin remembered. It is assumed that Edwin went to Cape Cod.

This is where Edwin's memories clash with the official record. Edwin said he remembered seeing his mother and father, Ida and Albert Snow, just before they had left for their vacation in Glendale, New Hampshire. His mother wanted to cancel her trip, but Edwin insisted they continue with their plans. His mother asked her friend, Mrs. Bassett, if Edwin could bunk in with them, and would she mind looking after him? The Snows left on their trip, leaving their sick son in the care of a neighbor.

Edwin was clearly uncomfortable at the Bassetts' and left their home. "I could not stand it any longer and I was made to feel that it was a privilege to be there," Edwin testified. Snow left Mrs. Bassett's and allegedly took a train back to Middleboro. "I started up the station and fell down three times," Edwin recalled, remembering the dysentery. "And the doctor came there and took me in his buggy and put me down at my aunt's in Middleboro and I do not remember anything after that," Edwin told the board.

After a few days in Middleboro, Edwin came back to Cape Cod. With his parents off in New Hampshire, young Snow was fending for himself again. Restless as ever, Snow decided to head to the Middleboro area again, but first he needed to finance the trip.

He went to see his high school teacher to borrow train fare. As noted earlier, the educator had no funds on hand. Edwin then went to see his father's brother in Barnstable for a loan. His Uncle George had no money to lend either. Just as Edwin was leaving his uncle's, an acquaintance, James Whittemore, was riding by. As he had done several times before, Edwin bummed a ride from Whittemore, and the two trotted off. As Edwin relived the murder of Jimmy Whittemore for the board, his testimony reiterated remarks made in 1914 before the same panel.

In its decision on the question of clemency, the board expressed sympathy that Snow had been in prison for so long. "Yet," the report concluded, "the frightful disregard of others' rights shown by the commission of the crime... that Snow lacked balance and was abnormal." The parole board would not take the chance that Snow would not seek revenge upon his release and it was "unwilling, despite the confidence in Snow inspired in many worthy citizens of good judgment, to take any responsibility for the release of this applicant from confinement."

Petition denied.

Many a disappointed prisoner might have stopped trying to secure his freedom at this point, but not Edwin Ray Snow. He was desperate for freedom.

So on November 30, 1918, Prisoner #12673 filed a petition to again apply for parole. It was his third application in four years. This time around, instead of a traditional, closed-door proceeding, a public hearing was held.

A petition to support Edwin's release, now part of his prison record, was circulated on Cape Cod, presumably by Edwin's father, Albert Snow. Among those who signed it was Idella Whittemore. "I think he has been there long enough to get out now. The family forgave him," wrote Mrs. Whittemore.

Several other members of the Whittemore family also signed the petition. Mrs. William Chase of Harwich—the former Hattie Whittemore, Jimmy's sister—put her name on the petition, as did Jimmy's younger brother, Clarence, who wrote, "I will forgive him for what he has done." Mrs. Whittemore's clergyman, the Reverend A. Judson Leach, who had visited with Edwin the year before and was now an advocate of his freedom, wrote that he thought "Mr. Snow was truly a changed man." The petition was posted to Boston, and lay upon the desk of Parole Chairman Frank A. Brooks during the parole hearing.

Edwin sat in on the hearing. The proceeding became the trial Snow had not had in Barnstable Superior Court in January 1900. After eighteen years, he was to come face to face with his enemies, those Cape Codders who were still fighting to keep him in jail for the rest of his life. "Snow…was permitted to conduct with great latitude the examination of witnesses who appeared in his behalf and to cross-examine those who appeared in opposition," wrote Parole Chairman Frank A. Brooks in a report filed after the proceeding.

Brooks and the other two panelists whose job it was to recommend or deny parole to the governor acknowledged that prison officials with whom Snow had worked and lived over the past eighteen years favored releasing Snow into society again. However, equal credence was given to those from Snow's hometown who with their last dying breath would fight his release. Surely, Frank A. Brooks and the others in charge of Snow's future had walked down this path before with Edwin. Everyone knew what to expect. For his part, Edwin was familiar with a parole hearing, from the way the chairs were set up to the demeanor of the three panelists who constituted the board. By now, Snow knew what type of questions to anticipate, and which queries to lodge at his opposition. "Clearly Snow wanted to be judged on the past eighteen years in prison, not by those who knew him as a troubled youth in Yarmouth," Brooks had written. The board never felt that Edwin Ray Snow was a "professional criminal," though a feeling also existed that "many men who are excellent prisoners are dangerous members of society when at large," according to Brooks. Perhaps other killers walked out of Charlestown as free men in a shorter period. However, clearly the advisory board catered to the fears and concerns of Cape Codders. What anticipation for Edwin Ray Snow. For the first time, he would be acting in his

own defense, looking into the faces of people he once played with as children, those playmates now grown into adults who were fighting so vehemently to keep him from having the kind of lives they woke up to each morning.

As in 1917, Cape Codders again mobilized to fight Snow's release, with several well-known Cape Codders in the lead. Barnstable County Sheriff Henry Percival, Judge Frederick C. Swift, Charles Bassett—chairman of the Yarmouth Board of Selectmen—and Yarmouth Selectman Edward T. Chase, a former classmate of Snow's, represented the opposition.

At Snow's parole hearing in 1914, Dr. Joseph McLaughlin, the prison physician, had called Edwin a "sexual pervert" and a "moral pervert" based on his homosexual act with a Cuban prisoner in 1907. It seems the doctor had changed his mind. Dr. McLaughlin testified that Snow was not a "definite sexual pervert." However, Frank A. Brooks would later write that while the board felt that single act should not cloud the potential release of Snow, it did not reflect kindly on his character.

Prison Warden Elmer Shattuck said, "Snow has spent more than one half of his life here, and I believe that after twenty years if he is ever to be considered for pardon that now is a proper time to do it." A civilian clerk at Charlestown shared Shattuck's sentiment. In his testimony, Edward Darling said he found Snow to be entirely honest in handling inmates' monies. "Snow has had charge of these accounts," Darling declared, "and in that position he would have an opportunity to do a good deal of work that could be of a very damaging nature and transfer money…to whom it did not belong."

Reverend Michael J. Murphy, prison chaplain, testified that he had known Edwin Ray Snow for seven years and found him "to be an honest, reliable chap and willing to faithfully…discharge duties which he has had." William S. Jones, a longtime guard at Charlestown, had known Snow for several years when he testified "Snow has worked here for two years in the guard room where I am stationed and I have found him very competent in his work." Snow was a man who had tried to make the most of himself, according to the Reverend W. Bradley Whitney, another witness Snow called in his own defense. "He came in here as a young man and instead of falling into a rut, has tried to develop himself mentally and has made himself a useful citizen of this community," asserted Reverend Whitney. Deputy Warden Hendry called Snow trustworthy and "upright in his work."

It is apparent that while Snow had failed as a citizen in Yarmouth in the outside world, at Charlestown State Prison he achieved success as part of a viable community.

Reverend Albert Crabtree, who had been at the prison during the infamous 1907 sexual incident involving Snow with a Cuban prisoner, described himself as a "rather hard subject to convince." However, Reverend Crabtree testified,

"In these eight years I have been as close to him as anybody, knowing his mental and moral workings…he is practically fit to go into society and be a helpful useful member of it."

Regarding Snow's homosexual encounter, Crabtree told the advisory board, "I don't think he ought to be judged from the one event which happened eleven years ago last January. I have known the characters that brought him to that and the temptations they bring to other men. I realize what that sort of man can do to anybody that is in prison."

Snow had a keen advocate in Crabtree, who told the advisory board that Snow "is out in the guard room in the morning before the officers are here practically with the doors open and had the opportunity to go out if he wanted to escape. He has handled accounts and has been honest." Crabtree found Snow frank and truthful. "I don't think any man has been trusted more," Crabtree asserted. "God will forgive Snow," he ended.

William B. Sanborn, a prison officer for fifteen years, oversaw the leather making production room at Charlestown and found Snow to be an intelligent young man. "Wish I had a shop full just like him," declared Sanborn.

Edwin received support from not only the petition and witnesses willing to testify on his behalf, but from a few letters too. Reverend Frederick B. Allen of the Boston Watch and Ward Society wrote that he was fully convinced that Edwin had learned his lesson, and "that his spirit and character show that he will be a help and not a peril to the community if released." Reverend Allen seemed to speak to those skeptics who truly believed that Edwin Ray Snow never could be reformed. In his decision on the parole bid, Frank A. Brooks appeared to have acknowledged Reverend Allen and others who felt that Snow was of exemplary character.

"It was argued by Snow, and may be argued by others with much force, that those who have had the opportunity to observe him during the eighteen years of his confinement are better qualified to judge his fitness for freedom than those on the outside who know of him only as he was more than eighteen years ago and who at best have seen him but occasionally since," Brooks conceded. Most of the people from Cape Cod who were enlisted by Cape Codders to formally oppose Snow's bids for freedom had never met Edwin. To the dismay of those who hated Snow, some of the "opposition" came away liking Edwin, even going so far as to say that he had paid his dues and hinting that Snow deserved his freedom. A good many others who knew Snow in his boyhood and continued to rally against him had not seen him since 1900. Snow's detractors had allowed themselves to take into account the changes in Edwin Snow in the last nineteen years. Some of the people fighting against his release were merely enlisted by their prominence to persuade the parole board repeatedly to deny any bid for freedom Snow might file with them.

Always eminently fair, the parole board conceded as much. "It may fairly be argued," Brooks would later write, "that the acquaintances of those gentleman who appeared in opposition ceased nearly eighteen years ago and their personal position is based upon eighteen-year-old acquaintance with Snow."

Parole boards of the early twentieth century appeared to have insisted that good conduct in prison was once the major, and in Brooks's words, "practically the only ground" other than innocence in granting freedom to a prisoner. In Snow's case, however, a unique set of standards seemed to exist, standards that included the social and political positions of Edwin's opponents.

It is not clear if Snow was able to question his supporters, but there appeared no reason to do so even if he could. However, when it came to his opponents, it was a different story. In 1918, Edwin was ready to fight for his freedom. The first witness was Judge Frederick C. Swift of the First District Court of Barnstable.

"Do you feel that anybody's life would be endangered by my release?" asked Snow.

"I am forced to say yes," replied Judge Swift.

Without hesitation, Swift said he drew his conclusions from having known Edwin since he was a child, and then as a juvenile delinquent.

"You were brought before me on the first charge of breaking and entering. I remember the circumstances of your being brought before me upon the complaint of murder."

Edwin asked Judge Swift to judge him as a man, not as the boy he had known eighteen years ago. Edwin, however, could not sway Judge Swift. "I formed my pretty positive conclusion as to the way you were made up, after my various experiences with you and I cannot change my mind."

Should a man of thirty-five "be condemned for what he was at the age of seventeen?" Snow pleaded with Judge Swift.

The judge's answer was that there was a difference between a man who has done a crime and is reformed and a man who pleads guilty to first-degree murder. "He is put here to protect the public and keep him away from the public. If it was a case of breaking and entering, I would look at it in a different light, but a man who has committed a deliberate offence, should not be trusted to go at large," Judge Swift asserted.

Frank A. Brooks listened to this encounter between Snow and Swift, saying nothing. His silence and occasional comments either allowed enormous latitude in questioning his opponents, or gave Snow enough rope to hang himself.

Raymond Hopkins, a longtime friend of Edwin's adoptive parents, testified next. In 1900, Hopkins was a junior counsel for Snow, assisting Thomas Day of Barnstable. Hopkins admitted to Snow and the others present that while Snow admitted to a plea of guilty in the first degree, "we know the Governor would change it to life imprisonment." Hopkins explained that John Knowlton,

the district attorney at the time, told Hopkins and Thomas Day that they could save Edwin's life by a plea of guilty in the first degree. Then the governor would automatically change the mandatory death sentence to life in prison. "And that was the agreement before he pleaded so that we knew absolutely by this plea he would come here and serve a life sentence," Hopkins recalled, adding, "he was but 17 and Mr. Knowlton was not willing that a boy of 17 should be executed."

If one reads between the lines, Raymond Hopkins, in 1918 a judge in the Barnstable Court system, admitted he did not think Snow would harm anyone if freed. Yet Hopkins remained evasive during questioning by Edwin.

"Judge Hopkins," Edwin began, "I have written you quite frequently since I have been here. Will you tell the board whether in your opinion I am a different man when this happened?"

"I think the letters are perfect," Hopkins replied, "he is a wonderful letter writer and I think they all show he has been getting along all right." That response was ambiguous and alluded only to Edwin's talent as a correspondent, rather than a prisoner's potential for freedom.

Raymond Hopkins treaded carefully during the parole hearing in 1918. On one hand, he was a judge and friendly with his colleague, Judge Frederick J. Swift, who had just ended his testimony against Edwin. Hopkins represented the people's interest, and the majority of Cape Codders did not want Edwin Ray Snow freed. "It would not be a nice place for him to come back there because they have allowed that feeling to remain of fear," Hopkins claimed.

Hopkins did shed light on court proceedings in 1900, when he had acted as Snow's junior counsel, when Edwin Ray Snow's fate had been decided. "He was not really tried," Judge Hopkins explained, "except that he came into court and pleaded guilty." By the time Snow pleaded guilty, a representative from the governor's office had already intercepted Hopkins and Thomas Day, alerting them to a deal of life in prison if he pleaded guilty to murder in the first degree. In fact, Snow's commutation of the death sentence was the first official act of the new Governor Murray Crane.

On the other hand, Raymond Hopkins had known Ida Huckins Snow since 1876, over forty-two years. He must have felt some obligation and loyalty to Ida Snow. "I think after nineteen years he is through with wrongdoing," Hopkins added.

Yarmouth Port Postmaster Theodore W. Swift came to Boston to testify against Snow. The Whittemore killing was still talked about in the town, as the townsfolk circulated a petition against Snow's release once they heard that another parole hearing was scheduled. "I was amazed in circulating that petition to find the unanimity of feeling [about Snow]," Swift told the board. "There was scarcely a person to whom I presented that petition who declined to sign it."

Swift tried to "educate" Frank A. Brooks and others on the Advisory Board of Pardons about the nuances of life on the Cape, especially in Yarmouth. "Yarmouth is peculiar in this respect that there are very many houses, quite large houses, large enough to house a dozen people in which there is but one or two people living," Swift asserted. "Many instances of women living alone and I find a quantity, a dozen perhaps, of women who said that if that parole or pardon were granted they should feel they must go elsewhere to live."

Villagers would feel, Swift continued, "considerably terrorized" if Snow were granted liberty. Everyone at home had heard about Edwin Ray Snow's stellar prison record, that he was an exemplary prisoner, but the element of doubt was strong enough to lend his or her hands to that petition against his parole. Swift, it seems, attempted to hand-feed Yarmouth's hatred of Snow to members of the Advisory Board of Pardons.

"It is reasoned out this way," Swift began, "that this boy lived in a good environment, furnished by his quite exemplary mother and father and was continually getting into trouble of one kind and another and finally got into such bad trouble that he was sent off to the Reformatory."

The Reformatory did not do its job well, those at home were quick to note, and Swift as their official ambassador was here to point that out. For just after coming home, Snow committed this "awful crime," as the postmaster described it. Swift's testimony keyed in on what had evolved as the seminal view on Snow's mindset. "They feel," Swift explained, "that he is capable of being a very good and useful man but if liberated that he is incapable of resisting his tendency to commit crime."

In the minds of Cape Codders, it would appear that the number of character witnesses Edwin Ray Snow snared on his behalf, be it five or fifty, wasn't worth a pound of lard. In their minds, Snow had never or could never do any good. It is clear that the Advisory Board of Pardons felt a keen responsibility to the interests of Cape Codders.

After Theodore Swift stepped down, John Clark, the secretary and treasurer of the Barnstable Mutual Fire Insurance Company in Yarmouth Port, a commercial citadel in the village since 1832, stepped forward. Like Raymond Hopkins, John Clark counted Albert and Ida Snow as close friends. In fact, when Edwin had been off at the reformatory in late 1989 and early 1899, Clark had boarded with the Snows.

Clark's testimony bore no cautious remarks, as had Hopkins's. "I simply ask the members of this honorable board if they lived in Yarmouth how would they feel [if Snow were freed]," Clark asked. When Clark had lived at the Snows' home on Main Street he would read the letters Edwin composed to his parents, in which he admitted his ways and promised upon his release to do right by them. "Then he comes out of reform school," countered Clark, "and did that

horrible, cold-blooded murder." John Clark made no secret of his dislike of Edwin, but called Ida Snow a very kindhearted woman. "A nicer neighbor you would not care to have," Clark asserted.

Edwin had heard enough. He was, after all, here to defend himself, and granted great latitude in questioning those against his release. Snow asked Clark if he thought him still capable of thievery and "apt to small peculations for stealing" as he had when he was a boy. In addition, Edwin said, he was responsible for the accounts of over $1,000 a month.

Clark's response was cleanly delivered and, like Swift's, voiced concerns about Snow. "As long as you are under prison restraint you will be a model prisoner," Clark insisted. "If you were at large every night I went out in Yarmouth I should have a fear." Snow lambasted Clark for not recognizing the "reverence" Snow held "for life."

"How can I?" came the response.

Still Snow insisted he should be judged as the man he was in 1918, not as the boy of seventeen in 1899. Snow longed for others who had known him in Yarmouth before the Whittemore killings to see his growth, note his maturity and know that he had learned his lesson, and then some. Yet despite his exemplary prison record, the vast majority of Cape Codders were unmoved by any good Snow had done or anything he had accomplished as a Charlestown prisoner. They were as fixed in their opinions and as unmovable in their beliefs as Maine granite.

As boys, Edwin Ray Snow and Charles Bassett had played together and roamed the streets of Yarmouth Port, sharing games and toys and good times. On that November day in 1918, however, Charles Bassett was not in front of Edwin Ray Snow as a friend, but as his enemy. Bassett said he traveled to Boston at the behest of villagers who asked him to represent their interests at the parole hearing. As chairman of the Yarmouth Board of Selectmen, Charles Bassett could hardly refuse his constituents. "The community has no confidence in Snow whatsoever as to his being a fit citizen to be at large," Bassett said.

Charles Bassett was accompanied by a fellow Yarmouth selectman, Edward T. Chase. Chase was no stranger to Edwin; as boys they'd been classmates in Yarmouth's public schools. Edward Chase had little to add to what Bassett said. Still Edwin Ray Snow questioned Chase about whether Chase was acting on his own opinion or that of others. "My private opinion," Edward Chase replied, "is only based on my acquaintance with you during the period of my going to high school with you." Apparently, that opinion was not a high one.

"Have you any personal fact that anybody's life would be in danger if I was released?" Snow asked.

"The only thing I can judge is by your past," was Bassett's retort. Edwin could do nothing more. But the parole board was not finished with Edwin. All

day the board had listened to Edwin question his opponents, and heard glowing character references from friends and personnel in Charlestown State Prison. Now Chairman Frank A. Brooks had a few questions for Edwin.

It appears that Snow had been writing various people, insisting that the board was not giving him a fair shake. Brooks and two other board members confronted Snow about these letters, now in their possession. They asked Edwin point-blank "in what respects the Board had failed to investigate his case and his claims upon the executive for clemency?" Edwin was unable to answer or give one aspect in which the board "had not made a fair investigation and he conceded that the hearing which was given him upon this reference was a full and fair one," according to documents and transcripts at the Massachusetts Archives.

The final decision of the Advisory Board of Pardons once again closed the door on Edwin's release. The board declared that Snow and his supporters failed to prove that his release would be "without danger to society," specifically Cape Cod society. Furthermore, their release of Snow would show the world that an "atrocious murder" case could, in Massachusetts, be punished by a mere eighteen years in prison. Brooks and his colleagues on the advisory board were not prepared to make such a statement to the world.

"If it would be unfair to Yarmouth and Cape Cod to release him upon them it would be equally unjust and unfair to release him upon any other community," Brooks wrote. On January 27, 1919, Frank A. Brooks rendered his decision, which surprised few, even Edwin Ray Snow. Petition denied. Edwin Ray Snow, now thirty-six years old, was to remain in prison.

Following Edwin Ray Snow's third failed attempt at pardon in late 1918, the winter of 1919 passed slowly and without incident for him. There were no disciplinary actions taken against Edwin and nothing about his schedule was abnormal. His letters to friends expressed a despairing heart at his continued incarceration, yet revealed an acceptance of his lot. Edwin plodded along during that long winter, engaged as always in his work.

He continued to have the trust of the guards, kindly administrators and the warden. Edwin moved about the Charlestown Prison freely, like a man roving through his own home. Edwin Ray Snow had grown accustomed to the sound of bells, clanging iron doors as they slammed shut for the night and prisoners' shouts in the night from distant cellblocks, the familiar banter of guards during the change of shifts as they exchanged news before they left to go home to their families. Snow had passed his eighteenth Christmas in prison, and more than half his life in a prison cell.

As 1919 progressed, Edwin appeared to others as the same hardworking, trustworthy prisoner he had always been. He appeared to have shrugged off the disappointments of three failed pardon hearings and resumed his bleak routine. Yet vulnerabilities existed within this headstrong man.

Edwin was depressed. His desperation ran deep and unseen like the source of a spring-fed pond, and unknown to others who guided Snow through daily life at the Charlestown State Prison. The people who feared and loathed even the sound of his name might have laughed at his gloom, even reveled at it from a safe distance, for they could always view his depression as rightful punishment for a cold-blooded killer.

Edwin felt cheated by his continued incarceration, and unknown to others around him, Snow planned to do something about it.

7

INTO HEAVEN AND HELL

J ust before Thanksgiving of 1919, Edwin Ray Snow escaped from Charlestown State Prison. Snow had the escape planned for months, and waited for the right moment to make the attempt. He weighed the risks of breaking out of Charlestown and felt that they were well worth taking.

Snow's depressed state of mind prompted the escape. "There is a limit to what the heart and the brain can endure," Snow admitted.

> *I was suffocated and had to have some air. I would never again carry a firearm, never seek unlawful pleasure, but I simply was obsessed with a desire to ride in a car and to wear a suit of citizens clothes. I had to do it or risk being shot trying. With not one hint, belief or hope that the door would ever open for me, shut tighter than it was a quarter of a century before and with every rightful, honorable, sacred emotion clogged and checked; absolutely disillusioned as to reward for merit, the power to compel recognition, and the ambition to gain my own; I felt cheated and became a man with one idea, albeit such a puerile one. A man without hope, or who can see nothing to cling to, is dead anyway.*

On November 26, 1919, at about 5:15 p.m., Edwin left the guardroom carrying a stack of newspapers. Snow routinely delivered papers to guards in a separate wing of the prison. Therefore, when Snow told several guards in the prison's Cherry Hill section that "I will be back later," no one thought anything of it. However, under that stack of newspapers was a package containing a "citizen's coat and golf cap," according to the warden's report.

"I took a key from the locker and went through a door in the wall. In the course of six months I did this planning, and abandoned it when my sense of honor asserted itself," he wrote years later.

After leaving the Cherry Hill section Edwin quickly walked toward the West Gate. Using keys stolen from the guardroom, he unlocked a padlock and door and

locked each door after him. "I kissed them goodbye," he said. "I procured clothes, money, keys; avoided dogs, 'trusties,' and guards, and went over the wall." Edwin climbed the stairs to the sentry box. There he slipped off his prison clothing, first his shirt, then his trousers, and donned civilian garb taken from a storeroom months ago. Snow put on a civilian coat, "walked to the southwest corner of the wall and by means of a rope which he had secured from the store-house," according to the warden, Edwin let himself down into the railroad yard. From the moment Edwin left the Cherry Hill section until his escape, only ten minutes had passed.

According to prison officials, Snow "went over the bridge beside the prison to the Viaduct Bridge, hence along Charles Street to a Brimmer Street garage." There, on the north slope of Beacon Hill, Snow hired a taxicab to take him to South Boston. It was about ten minutes to six when Edwin reached South Boston. The person he was trying to look up, a friend of a friend from prison, was not at home. "It was suggested by a man in here that I go to the house of a friend of his and hide till I was outfitted. This was just a play on my distraught credulity, as he sent officers right on my heels," Snow claimed. Edwin said he felt like a fly in a bottle—he could not reason a plan.

Snow panicked; he could not think of what to do next. He decided to go where he was familiar with the terrain—to Middleboro, site of former good times and pleasant, youthful memories. Edwin hired a taxicab. "Out in a strange world I could not figure what to do next. So I told a taxi man to take me to Taunton, the only city I could find my way out of," wrote Snow. Edwin said the taxi driver took a wrong road at Bridgewater "and landed me in my home town of Middleboro."

The ride went smoothly through Avon and Randolph. Just before getting into Randolph, the cab's tire required immediate repair, and the taxicab driver and his passenger were forced to stop at a garage for help.

Edwin was elated, but he did not think clearly. From the garage, he telephoned an old girlfriend, Eloise Doherty, at home while the cab was being repaired, and left his name at her home. Eloise's father, Edward, a man for whom Edwin had once worked, answered. Eloise was still at work, Mr. Doherty explained to Edwin. Snow made a second phone call to Eloise herself at her place of employment.

"He told her that he was on his way to see her, that he had escaped from prison," according to the warden's report. Eloise was so shocked she fainted. Someone picked up the phone and said the party with whom he was talking had swooned. When Eloise regained consciousness, she was understandably a nervous wreck. In the meantime, Edward Doherty had notified the Middleboro Police of Snow's escape. They, in turn, contacted the state police, who phoned Boston to relay the news to officials at the Charlestown State Prison. A guard checked Snow's cell but he was gone. It was 9:05 p.m.

Snow, oblivious to the mobilization of law enforcement officials, and his driver left the Randolph garage for Brockton. In Brockton, Snow and his driver stopped at a store where Edwin bought a shirt, collar and necktie and a fedora, using the money he had stolen from fellow inmates. As Edwin admired his new clothing, local police at numerous departments in southeastern Massachusetts headed out the station doors to hunt him down.

When Edwin and his driver grew hungry, they stopped to eat at a diner and ordered coffee and sandwiches.

For the first time in twenty years, Edwin Ray Snow was served a meal, just like any law-abiding citizen in the civilized world. As the duo ate, "they…were reviewed by police officers as suspects," a prison report noted, "but nothing was said, and they proceeded towards Bridgewater." As Edwin ate and sipped coffee, much of southeastern Massachusetts was in an uproar over his whereabouts.

Parts of the Snow escape story are laughable. On their way to Bridgewater, Edwin and his nameless driver were lost for an hour. Finally, they picked up the road to Bridgewater and reached Middleboro Six Corners at 10:30 p.m. There Edwin dismissed the driver and gave him forty dollars for fare, once again a liberal spender with the money stolen from inmates at the Charlestown State Prison.

Edwin Ray Snow walked the streets of Middleboro alone. He passed places, buildings and homes he had known as a youth and realized how much his old world had changed. "I was a happy man, again but eighteen, when I passed down the familiar streets of my boyhood. I just wanted to walk and smoke, all night long, in the wet and storm, so elemental and joyful did my old home seem to me," Edwin wrote.

For Edwin, unaccustomed to exercise, the night proved exhausting. "I walked fifteen miles through woods and bushes, ran or stumbled or fell in ash piles, mud, ditches and hen yards for two hours, and did not so much as catch cold though I did become very lame," he admitted. He had worked so hard to plan his escape at considerable risk, yet he did not seem to be enjoying the venture. "The movement and ease of the crowds, the preponderance of young, cocksure people, made me feel out of place, unacclimated, without home or destination or resource," he conceded.

This, as corrections officials at Charlestown were eating crow. Middleboro Police, alerted by Edward a few hours earlier, were frantically searching for Edwin Ray Snow. The state police, called by Middleboro authorities, launched their own search for the escaped murderer. It must be assumed that police departments nearby were notified that an escaped murderer might be in their midst. It is probable that authorities on Cape Cod, particularly Yarmouth, were also notified of Edwin's escape.

An undaunted Snow dropped by the Doherty home. An angry, panicked Edward Doherty answered the door. "Miss Doherty's father…informed him

that his daughter was very sick and could not see him and advised him to hasten away, that the police were looking for him," according to the warden's report, which also stated, "Doherty immediately notified the police that Snow was in the neighborhood."

After leaving the Doherty home, Edwin headed toward Middleboro Centre, where he was arrested in front of Bob's Lunch and taken to the police station.

En route, Snow broke away from the officer, his second escape that night. Years later Edwin wrote he remembered being "cornered, shot at, I had the feeling I was less than an animal, and helpless as a child. I made no defense, could not strike back. I have lived too long with men and stories where lives have been forfeited, liberty lost, over such trifling acts and causes, that I cannot see a thing in the whole world, or a person, that could induce me to handle a gun or commit a crime for," Snow added.

He wandered around Middleboro and then met up with another police officer, whom he convinced he was not the escaped prisoner.

"I felt every step was a false move and every word a bad break," he admitted. "It is strange. I had no fear of the many shots fired at me, but what a contrast between a fugitive and a law-abiding citizen! I felt that!"

As he had done the night he shot and killed Jimmy Whittemore on September 13, 1899, Edwin fled into the shadows of the night.

Edwin's self-styled biography told of his fears the night of the infamous escape. "I walked dark, moonless road, stroking and talking to the bark on the trees—and all men could make of my distress was that I wanted to see a girl," Snow remembered.

Edwin Ray Snow was recaptured, this time for good, at about 12:30 a.m. "on the road to East Taunton…by Chief of the Fire Department Maxim and Officers Hasty and Jackson," who, according to the prison report on the escape, "Snow had held up and asked for a ride to Taunton." Whether due to his arrogance or plain exhaustion, Snow had walked right into the clutches of the police officers. One by one, the departments in Brockton, Middleboro, Lakeville and surrounding communities were notified that Edwin Ray Snow, Prisoner #12673, was back in custody. Corrections officials at Charlestown must have breathed a sigh of relief, as did all of Cape Cod.

Edwin returned to Charlestown State Prison under heavy guard and solitary confinement. He told Warden Elmer Shattuck he was glad to be back.

"Well, you've made a nice mess of things, Snow," was all the warden told him.

"I temporarily lost all sense of decency, and ignored the demands of gratitude. I occupied a position of exceptional trust, and though my position enabled me to get away I did not betray the trust," Snow wrote later. "I received privileges in the way of special liberty of movement, ate at the hospital dining room, and had a drop lamp and many things not possible to a man in the free world."

In his report, Warden Shattuck claimed that Edwin had planned the escape "for some months" and had kept the clothing he needed "in his closet in the guard room for 4 months." Snow had somehow found rope needed to scale the wall and he had had the rope for two weeks. He stole $130 from "inmates of the prison and in the sale of merchandise which belonged to the prisoners' trust fund," the report stated.

During Snow's confinement, it became clear to him that the guards who minded him and the other inmates were affected by his escape. "I have always been in close contact with the officers," Snow reminded readers. "Ordinarily they are impersonal, disinterested, duty performers. In this hopeless situation, with everything jumbled, they have by their tone of voice made me heartily ashamed that I ever doubted their good wishes and confidences," he conceded.

As Edwin sat in solitary confinement, he surely came face to face with a sad epiphany: he was a failure living among failures. "In the dark of solitary confinement, sitting on a wooden plank, waiting for bread and water, it is twice as long," Edwin remembered in late 1919. "A sensitive man cannot sleep, walk, rest or think. It is just a coma of waiting," Edwin said of solitary confinement. Solitary affected each man differently, according to Snow. "Some are scared by it, some broken in spirit, some hardened and embittered, some unaffected. That it is a deterrent is doubtful."

Soon after his solitary confinement ended, Warden Shattuck ordered that Snow be examined by a psychologist "to detect abnormalities." Edwin reported the clinical findings to readers of his autobiography.

> *The worst he could conclude was that I have a streak of conceit and an inferior personality. He was right. Enthusiasm and zeal had made me take myself and my job too seriously.*
>
> *I greatly overestimated my value to those I tried to serve, both in method and results. An inferior personality may be developed into a superior one when his association is with womankind and away from subjection to the will of others.*

In this writing, Edwin sounded suspiciously like a psychologist himself. Apparently Edwin longed for a mate, a wife, with whom to share his life.

The aborted escapade compromised the faith others had placed in Snow. Edwin failed them, in the eyes of corrections officials, the Advisory Board of Pardons, even members of their respective communities. The people who had put themselves on the line by publicly advocating his freedom felt betrayed by Snow's escape, and were perhaps seen by others as unable to judge human character and see flaws in Edwin. In the plainest of words, the prison escape was a downright selfish thing for Edwin to undertake. It proved a tactical error of the grandest magnitude, endangering future chances of parole.

By escaping, Snow had provided his enemies with powerful ammunition. The escape validated his enemies' assertions that Snow was untrustworthy, a thief, a liar and apt to commit more evil crimes if paroled. Men such as Edward Chase, Snow's old classmate and now Yarmouth selectman, could boast with absolute certainty that Snow was unfit to enter proper society. Now Charles Bassett, Edwin's childhood playmate, could walk around town and assure Yarmouth residents that if they ever believed in Edwin's worth as a free citizen they could forget those thoughts.

Every portion of Edwin Ray Snow's personality played a role in his escape. His self-honed intellect had brainstormed the escape, yet he stole clothes ill suited for warmth. His will had edged him toward the outer wall and led him to civilian streets. As prison escapes go, Snow learned an important lesson. If pardoned, acclimating to a new world where the automobile had replaced the horse and carriage would be a tremendous challenge.

In the months following the escape, Snow was ostracized by the inmate population, the Charlestown staff and administration, as he had been in 1907 following the homosexual incident with the Cuban inmate. However, this time, twelve years later, Edwin "felt at ease." His depression, his gloominess, left him. "I had freed my system of the accumulated poisons of months of brooding," he wrote. "Prisoners take their cue from their superiors, or curry favor at the expense of one who is in bad," Snow explained, yet he did not care this time around. "Their attitude was no loss, and was replaced by a superior gain. Instead of brooding over ingratitude, I had kind and thoughtful deeds to think of."

In a sense, prison itself was an escape from the outside world, allowing Snow adequate time to educate himself, discipline himself, secure training in craftsmanship and bookkeeping. Charlestown State Prison was the university Edwin had never attended.

Most pitiful about Snow's prison escape were the men he disappointed— people who had supported him through several pardon hearings, friends who had put their own reputations on the line in an effort to secure his freedom, intimates who swore to the Advisory Board of Pardons that Edwin was "trustworthy," "honest" and a caring human being.

Edwin would have to answer to them all, one by one. Edwin would also have to explain this latest misstep to his aging parents, Albert and Ida Snow. Edwin would also have to face William Sanborn, a fifteen-year veteran corrections officer at Charlestown State Prison who had just testified in Snow's favor at his recent parole hearing. Sanborn supervised Snow in one of the prison's industrial shops. It was Sanborn who said with such confidence that "I wish I had a shop full just like him." Snow would have to look into the eyes of another advocate, the Reverend Albert Crabtree, who also testified, "I don't think any man has been trusted more."

What of his inmate peers? Edwin had been trusted with their monies and turned his back on that responsibility by absconding with their funds. Snow was now a thief among thieves. He was impulsive by nature, destructive in deed, undisciplined and unproductive, except in a highly structured environment such as prison. However, a facet of Edwin's nature that infuriated those who despised him yet surprised and often delighted his advocates was his steely backbone. Within weeks of his escape from Charlestown, Snow appeared to have bounced back, smiling, working hard and blaming others for his missteps.

Several weeks after Snow's botched escape, the *New Bedford Sunday Standard* asked Edwin to pen his autobiography for its December 28, 1919 edition. Snow was an articulate man and a convicted murderer, making him an object of both curiosity and contempt. His story would sell newspapers.

The edition also included a lengthy interview with the infamous inmate by reporter Elizabeth Bowie. "Warden Elmer E. Shattuck had opened a heavy door and led the way into a great room which serves as a reception room for the prisoners," she wrote, "The door clanged shut and locked. Two sides of the room were opened to the ceiling except for iron gratings painted white. Behind them one could see winding staircases, and it was down one of these that Snow came when the warden sent for him." Edwin carried to the interview the autobiography he had written. "This he turned over to the warden for consideration and the interview proceeded," she wrote.

Edwin and his interviewer sat across from each other at a visiting table. "Occasionally a guard strolled by, close enough perhaps to overhear the conversation, but passing on without much show of interest," she wrote. "The room began to fill with people, prisoners who had been brought to the assembly room for a brief visit with friends and relatives." The pair sat at a table in the center of the room. All of a sudden, Edwin appeared unhappy. "Guess we'll have to move. They've received someone," he told his guest, noting the entrance of a new inmate at Charlestown Prison. "And he led the way to a corner of the room where not even a guard came within earshot, while the man, entering the prison as an inmate, was walked through to his cell."

Edwin's short-lived escape from Charlestown Prison the month before proved the reason for Miss Bowie's visit to Charlestown. "It struck me suddenly that out of twenty years of life, these hours were the ones different enough from the rest, thrilling enough, significant enough for the lifer to dream of and talk of for the remainder of his days if he should spend them behind bars," she noted of the illegally gained hours when Snow had walked as a free man.

The interviewer and Edwin appeared to like each other. Judging by Bowie's text, they talked easily and without hesitation. Ironically, this was the closest Edwin had gotten to a woman in nearly two decades. For her part, Elizabeth Bowie appeared formidable, actively working in a man's world, unafraid to

ask pertinent questions of others. Snow answered Bowie's questions without missing a beat. "His words, couched in a language of a student and thinker, came quick and fast. He knew that the time was limited and he had much to say," she wrote.

Edwin was oblivious to the sights, smells and sounds of a state prison. The clanging of a cell door was familiar to him, but not his interviewer.

> *There was an incessant dull clanging of doors and turning of keys and ringing of bells. Guards, dozens of them, most of them six feet or over, patrolled the room and stood on the stairways. A weird procession wound silently up and down those stairs, suggesting for some inexplicable reason, an extravaganza at the Hippodrome where gaily clad girls and men climb pasteboard staircases to the blare of bands. Only this time the procession was made up of men, dressed just alike in prison gray, on their way back from lunch to different shops where they are employed.*

Charlestown State Prison was spotless, she observed. "There was an indescribable faint odor. It was faintly antiseptic, but musty and a little damp." Charlestown State Prison was nearly 120 years old and beginning to show its age.

So was Edwin Ray Snow. "He looks his age, 37, except for the youthfulness of his smile and his thick brown hair, which is only touched with gray on the temples," she noted. The reporter clearly was not repulsed by Edwin and wrote sympathetically about him, though it might be saying too much to read between the lines of the aging newspaper to think she might have been attracted to the inmate. "Snow's eyes never wavered as he talked," she wrote. "They are brown, with little laugh wrinkles around the corners as they twinkle amiably when he is amused. The prison pallor is not noticeable even after twenty years of confinement, at least in the prison light."

Whatever her immediate reaction to Edwin Snow, the reporter detailed his physical appearance down to the last minute detail. "He is sturdily built," she wrote, "with broad, heavy shoulders, slightly rounded and an extraordinarily springy walk considering the infrequent exercise of prison life."

Edwin turned the tables on his interviewer and asked Elizabeth a few questions. "Do you think I have injured my case by my attempt to escape?" His question was rhetorical: "That I can't answer. I may have or may not, there is no precedent in such cases. There can't be," he reasoned, "each has to be judged on its own merits."

Still, Edwin admitted the entire escape escapade was not worth a hill of beans. "He seemed genuinely sorry for the betrayal of faith which occurred just before Thanksgiving," Bowie wrote, "when for two days free, though hounded every minute of the time after the first two hours before his escape was discovered." (Snow was actually free only about seven hours.)

1. The Bass River Bridge linked the South Yarmouth village of Bass River to West Dennis. *Courtesy of the Dennis Historical Society.*

2. The Yarmouth Port Library was central to village life in 1899. *Courtesy of the Historical Society of Old Yarmouth.*

FIRST CONGREGATIONAL CHURCH,
YARMOUTH, CAPE COD, MASS.

3. Social events in Yarmouth Port often revolved around church. *Courtesy of the Historical Society of Old Yarmouth.*

4. The quintessential Cape Cod homestead. *Courtesy of the Historical Society of Old Yarmouth.*

5. Weir fishermen in Barnstable, circa 1896. *Courtesy of the Barnstable Historical Society.*

6. Small fishing schooners and catboats tied up along Bass River, with the Bass River Bridge in the background. *Courtesy of the Dennis Historical Society.*

7. Thousands gathered at the Barnstable County Fairgrounds every summer. *Courtesy of the Barnstable Historical Society.*

8. One of Yarmouth's two train stations in the early decades of the twentieth century. *Courtesy of the Historical Society of Old Yarmouth.*

High School, Yarmouthport, Mass.

Pub. by R. H. Harris.

9. Edwin Ray Snow's high school in Yarmouth Port. *Courtesy of the Historical Society of Old Yarmouth.*

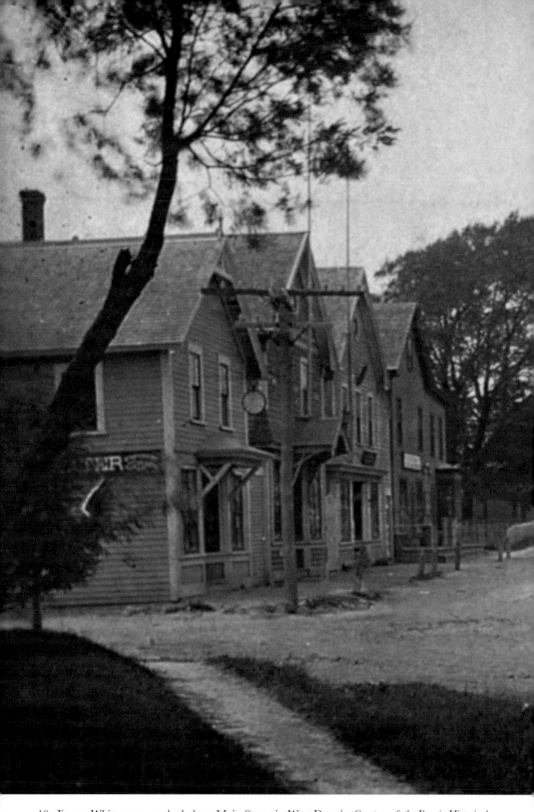

10. Jimmy Whittemore worked along Main Street in West Dennis. *Courtesy of the Dennis Historical Society.*

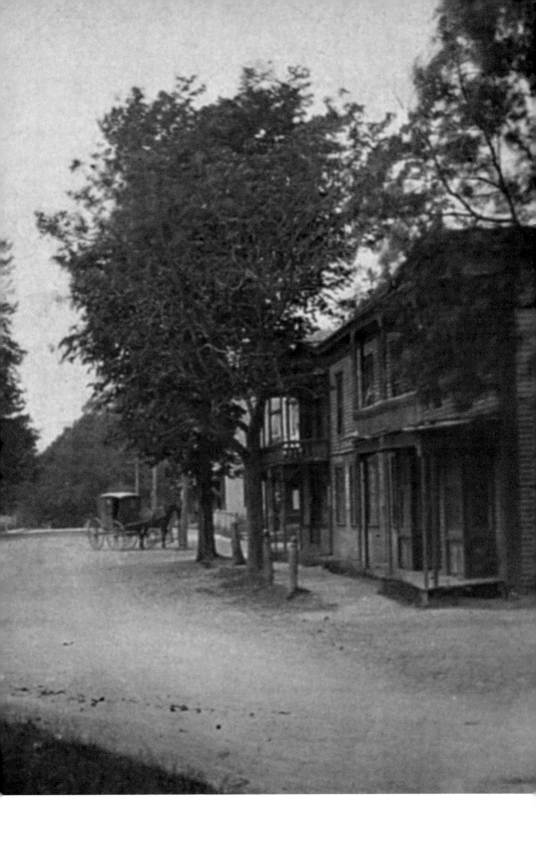

11. Commerce thrived quietly in the heart of West Dennis during Jimmy Whittemore's short life. *Courtesy of the Dennis Historical Society.*

12. A mansion in West Dennis along Jimmy Whittemore's bakery delivery route. *Courtesy of the Dennis Historical Society.*

13. Young Whittemore would have traveled along this vista overlooking a pond, marshes and into Cape Cod Bay while in Barnstable. *Courtesy of the Barnstable Historical Society.*

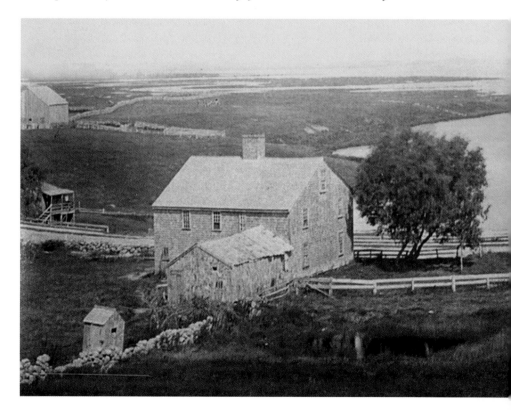

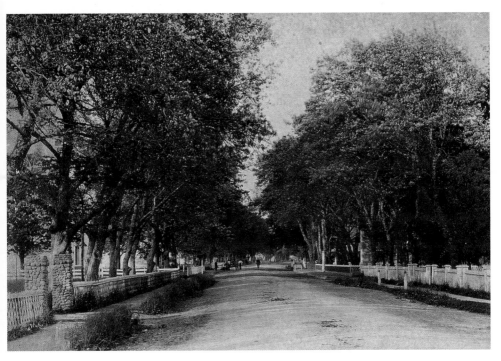

14. Main Street, Barnstable Village, often traveled by Jimmy Whittemore on his bakery rounds. *Courtesy of the Barnstable Historical Society.*

15. The last time Jimmy Whittemore traveled through Yarmouth Port was along Strawberry Lane past the village common. *Courtesy of the Historical Society of Old Yarmouth.*

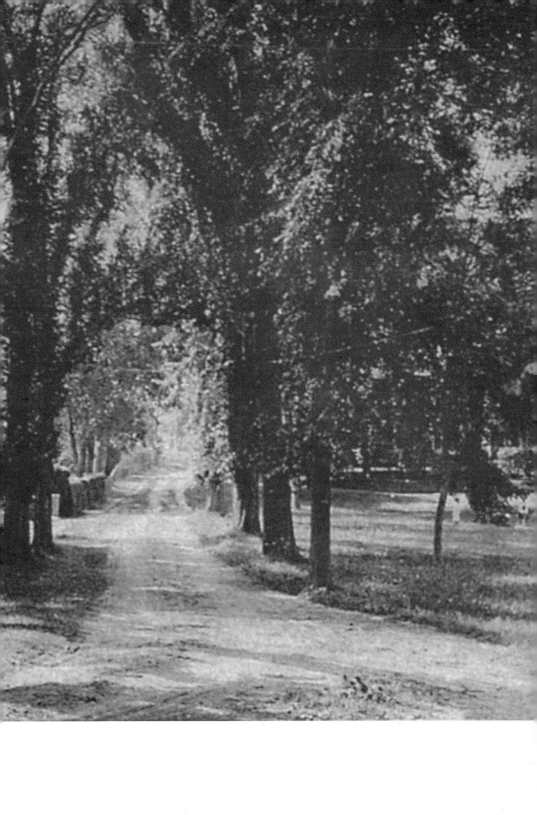

16. Young Whittemore would have used a bakery cart, or wagon, similar to these fish vendors'. *Courtesy of the Barnstable Historical Society.*

17. Jimmy Whittemore lies buried in the graveyard behind his family church in South Dennis. *Courtesy of the Dennis Historical Society.*

18. Edwin Ray Snow's fate was decided inside the Barnstable Superior Courthouse in Barnstable Village. *Courtesy of the Barnstable Historical Society.*

"He wants to get out," observed Bowie. "It is plain, too, that it is the daily hope of some turn in the luck, some unexpected development, the ultimate conversion of those who have it in their power" to one day free Edwin, she added.

Snow's autobiography appeared alongside Bowie's interview. He felt his was a story worth reading. "No doubt in my mind holds many reminiscences that would interest the public," he wrote. Edwin explained that he never knew very much about his birth parents. "Of the alliance that gave me birth I know nothing, and at this late day I have no desire to investigate," Snow stated. "They who claim I am hereditarily bad have no more light on the subject." People state what they want to believe, according to Snow. Edwin said he never wished to know about his birth parents. Besides, he wrote, being an only child carried its perks. "I have always had as much as, and often more than other boys in the way of clothes, toys and training influences," Edwin remembered.

Edwin never spoke an unkind word about his foster parents, Albert and Ida Snow. "My earliest memory is of my present foster-parents, and my last thought tonight will be of them," he commented with affection. "They have never ceased to care for me or believe in me."

A compelling section of Edwin's autobiography was devoted to events of September 13, 1899. He recounted the Whittemore slaying, matching testimony of earlier parole hearings. Edwin intimated that the only reason he shot and killed Jimmy on September 13, 1899, was because he was young and had been drinking, which made him ill. "It must be borne in mind that I was but 17 years old," Snow wrote. "Away from all restraints, in a strange city, I could not suppress all the exciting tendencies," he said, remembering how much fun he was having in Middleboro and Lakeville, much larger communities than Yarmouth. "However, a fortnight after I secured my job in the machine works, I became sick, and the illness left me weak, mentally and physically. After several days of fever and fasting, I drank some liquor," Edwin wrote. In reality, Edwin had been drinking, according to his testimony some years before, for nearly two weeks straight. "Primarily this caused the commission of a murder."

Edwin also insisted that if he could have borrowed money to go back home to Taunton, he would have left Jimmy alone. "After vain attempts to borrow carfare I rode with a young man who drove a bakery wagon," Edwin said. "He was not my chum, or even schoolmate, but a resident of another village."

Nearly twenty years after Edwin pulled the trigger of the revolver that ended Jimmy Whittemore's life, he still had trouble admitting he alone was responsible for Jimmy's death; not the fact that he was drinking, nor sick nor in dire financial straights, as he was lacking even two dollars for a train ticket back off Cape.

Purely by unfortunate circumstances I had a revolver in my pocket. At the end of my ride, going through a stretch of wood, without any malice or

premeditation I demanded the boy's money. When he grabbed the gun I fired. I was arrested, pleaded guilty, and was sentenced to die in the electric chair. The counsel, appointed by the court considered me a child, and acted accordingly, by avoiding a trial and securing a commutation of sentence. I cannot by self-flagellation give back the life I so wantonly took. At that time "the sacredness of life" was only a phrase to me.

Snow had the attention of anyone reading the *New Bedford Sunday Standard* on December 28, 1919. He made a pitch for his freedom via his readers. "But as the mother and three relatives of the murdered boy have forgiven me in person and asked the governor to show clemency, I feel that even so terrible an act can be expiated," Snow penned.

One wonders what Cape Codders thought of Snow when they read his self-styled story. Surely, some people had heard of its publication and made sure to scour the article word for word. They were probably disgusted with Snow all over again, as he reminded them of his unwelcome presence in their lives. Ever odd in the way he reasoned his life, Snow was adamant that the prison got the best of him. "The best that was in men has been expended for the prison and the men, and their worst and best has flowed in to me," Edwin declared.

To his credit, Snow used the chance given by editors at the *New Bedford Sunday Standard* to admit the "somber act" with the Cuban in 1907.

Since this is a frank recital, it is not my intention to slur or evade any incident belonging to a complete record, so I must allude to a somber act of twelve years ago, one factor in the process of learning to live right. It has been magnified, distorted and inverted by my enemies, and by those who always stand aghast at any occurrence outside the normal. I participated in a deviation from moral law and incurred the loathing, with all the attendant disapproval and ostracism, of my fellow man…From the lowest stage to which a man may fall I beat back, and by test and trial and proof compelled the testimony of repentance and uprightness, and under conditions that cannot be refuted.

Snow's remembrances blended with past testimony about the Cuban incident.

Of the recent prison break, Edwin penned, "The most significant lesson that has been presented to me through this peculiar act is one I hesitate to speak of. I am in a way mystical and see meaning in a commonplace. The body of itself has no power, the mind is stronger than the body, the soul is higher than the mind."

Clearly, Snow put much stock in his ability as a worker. If Edwin Ray Snow could not have a successful career in the civilian world where men walked the

streets freely, then he sought success in the prison industries where, he wrote in his memoirs for the newspapers, "ones entrusted with the duty can reason clearly, labor effectively." Officials at Charlestown State Prison made the most of Edwin Ray Snow. He claimed he was "assigned to work as harness and bag worker and instructor, cutter for the mattress and upholstering departments, librarian, messenger, and bookkeeper; I taught commercial subjects of English, Algebra and Spanish for twelve years; I worked on novelties in my spare hours to have an income of some sort; and I have been an attendant at the Episcopal chapel."

Snow used the newspaper as a platform to gather support for future bids for parole. Undoubtedly, Snow hoped the article would garner additional advocates, who grew in number by the year. By late 1919, when his autobiography appeared in the *New Bedford Sunday Standard*, Edwin had accumulated an arsenal of friends.

> *There are those to whom I owe a debt of gratitude; those who have advanced me sums of money; those to whom I am indebted for knowledge; those who have enforced the obligations that only love may impose. All of these, in my own time and my own way will be paid, fully and gladly, if life and liberty are granted, and in such way as to sweeten all the future years by compensating for all the sad years.*

Still, Snow had betrayed the trust of many when he stole monies and escaped from Charlestown Prison. "My friends, my self alone, with the support of the entire administration from the commissioner down, have carried my cases through every stage right up to vote, that would have been favorable," Snow claimed, "and we were blocked by a personal prejudice." It is assumed the "personal prejudice" referred to the organized movement against his release by Cape Codders.

"We offered a duplicate of every reason and merit and prospect that was ever advanced in any one of the eighty cases that have won release—time served, faithful labor, ability, character, and future provision," Snow asserted, explaining that on occasion men who committed murders were paroled after having served shorter sentences than he. "The final decision," Snow wrote, "was that I could not show that I would not commit a second murder; but neither can they point to one who has."

Edwin wrote of the hatred that many former friends bore him. "However, they who bear false witness cannot restore what they take, nor they who damage hopes. For years meddlesome people fanned the flame of hate that centered on me," he conceded. Those who read Snow's self-promoting newspaper article were exposed to the defensive outbursts of a man who felt persecuted by his

former Cape Cod neighbors. "They had not seen me for twenty years and do not want to for another twenty more," Snow wrote. "If they die, their children will carry on," Edwin insisted. "They object to my parole because as a boy I was 'impulsive,' 'dishonest,' and had 'homicidal tendencies,' and 'they would fear to go home at night,'" Snow quoted his enemies as saying.

Interestingly, through all the meetings and hearings and writings in which Edwin Ray Snow had been involved in the past two decades, he rarely if ever uttered, either in speech or in print, the name of the man whose young life he had ended.

In one of the final sections of his autobiography entitled "His Relations with Women," Edwin Snow denied having impure thoughts. "I have never harbored in my mind, nor expressed in my conduct, any motive of impurity or ungentle manliness towards any woman," Snow confessed. "These purposes impute to me, and the base insinuations regarding generous, refined, noble ladies who are my friends, should not have been used to sully the columns of a public journal or distress the persons named." It must be assumed that various newspapers had printed the names of Edwin's female advocates, perhaps alluding to a sexual or romantic alliance between these woman and Edwin.

Edwin concluded his life story by thanking people who stuck by him in deplorable times, namely his longtime Boston attorney, A.H. Bacon, "who, without thought, or prospect of fee, worked so thoroughly and untiringly for me."

"I firmly believe that society, that vague coat hook for all narrow spites, will give the chance to any man once it is acquainted and convinced of his regeneration," Edwin asserted. Clearly, Edwin was grateful for the opportunity to put into print what he long felt in his heart and mind.

> *That I am allowed to write this article, or defense, sought by* [the *Standard*] *offers for public consideration one important and undebatable fact. The promise of newer men who are taking control of penal matters are sincere pledges. They want the prisoner's rights respected and protected; and his hopes to have a guaranteed foundation. In theory or opinion this has always been so, but now it is actually so. I acknowledge with real Christmas joy the liberal mindedness and goodness of the warden; and I thank the editor for the services of his pages.*

Edwin Ray Snow settled into his winter routine at the state prison in Boston, working as the "Bundle man for the Underwear Department."

Prisoner #12673 had been at Charlestown State Prison for twenty years.

8

WE BELIEVE HE IS
AN UNSAFE MAN

The years following the 1920s were productive and peaceful for Snow at the Charlestown Prison. Once inmates got past their initial shock and outrage at Snow for stealing their money and trying to escape with their funds, Edwin's saga turned him into a folk hero. Even hardened criminals grudgingly admired Snow's spunk for at least trying to leave.

From 1920 on, Edwin saw himself as part of a changing world. Writing about his prison experience many years later, Snow observed that "prison during these years, has undergone a radical change. A man today is a very part of the free world except in physical movement; and is preserved mentally and morally, physically and spiritually, and prepared and supported in an effort to become a law abiding citizen."

Edwin corresponded with outside supporters, though no letters are known to have survived. His prison escape had not injured his precious friendship with the Reverend Spence Burton of the Society of St. John the Evangelist. Father Burton, an Anglican priest, frequently visited Edwin at Charlestown Prison, as well as other inmates under his pastoral care. Edwin shrugged off the prison break as "an impulsive wanderlust, a temporary abrasion quite different from the selfish, anti-social, murderous scheming of a confirmed criminal."

Of the prison system, Snow wrote, "I date my own conception of my true place in the world from the ninth day of December 1919," possibly recounting the day his solitary confinement ended and he felt reborn. "I have met friends who have presented a new perspective and restored me to normality; friends who would not let me be defeated by the Past." It can be assumed that Snow's friends, or at least some of them, also shrugged off his prison escape as wanderlust and resumed their friendship and trust.

If 1920 marked a turn where Snow felt better about himself, there still remained a lingering depression from the plot to escape the previous November. His reputation was damaged. "January 1, 1920, I was for the first time in my prison

experience without a cent of money, deserted by my parents and many friends, repudiated by my church priest, and on the black book here," Snow achingly wrote many years later. Prisoners were responsible for buying essential toiletries and other liberties, so it may be assumed that Snow went without basic sundries.

Two acts of unexpected kindness from other inmates eased his isolation. "Two strangers, in my shop, volunteered and provided me with every need for six months till I could hit on some way to support myself in what I was accustomed to. In such straights, and no longer ready to start or develop confidences I turned to books," he claimed. "I wrote to the Old Corner Book Store and asked them to trust me, indefinitely, for about $25.00 worth of books," recounted Edwin.

Those two incidents of human kindness extended by strangers to Edwin, the financial assistance from the shop inmates and the loan of books, had a strong impact on him. "I had an immediate response from Mr. [Richard] Fuller, and a visit from him. He added two baseball mitts, and a fountain pen, for good measure," Edwin fondly recalled. "I shall always feel that this one bit of kindness by an unknown man started me on a new path."

From 1920 to 1921, Edwin "did every sort of craft work available by which I could earn ten cents an hour in my leisure," he reported. He worked in his cell, well into the night, for a chance to earn extra money.

A year after Edwin's escape Deputy Warden Hendry, according to Snow, said, "Snow, your probation is over. I'll give you another chance." Snow's prospects were brightening. "He placed me on a trusted, specialized job as clerk for the superintendent of industries, where I kept account of all the invoices and sales of all manufacturing departments," Snow proudly recalled. "The Honorable Sanford Bates put his library at my command," Edwin added; this is the first mention of someone named Bates.

"Life seemed lenient," Edwin observed. However, the tranquil times, as always, did not last.

"In the middle of the year I was notified my father had dropped dead on his way to work, no sickness, no warning, and no savings put by." Albert, almost seventy-one, had died of a heart attack. Edwin was devastated. Nevertheless, from within his prison, he could do nothing to comfort his mother or properly grieve for his father.

Regret and sorrow quickly filled Edwin's heart. "I had not seen him [Albert] since my hearing three years before," Snow recalled. "I had planned and dreamed and hoped to be able to do something for his sacrifices and care. Time and again I go to his example, for I had to lose him to realize what a remarkable, capable dutiful, worthwhile man he was."

Albert was buried at Woodside Cemetery on June 10, 1921. Edwin did not attend his father's funeral. We must assume an option to do so did not exist; had

it, the people of Cape Cod would not have heard of it. Albert C. Snow's will was probated on June 27, 1921. His net worth, even by standards of the day, was modest. His carpenter's tools were worth $100. The furniture in his house was valued at $230. Albert C. Snow, for all of his hard work and labors, had left his Ida $197.86 to live on. Edwin Snow was also a beneficiary of Albert's will, but took nothing from his paltry estate, leaving everything for his mother. Apparently Albert had reinstated Edwin as a beneficiary after removing him from his will following his murder conviction in 1900.

Soon after, kindly Warden Shattuck gave Edwin $250, "and started me making leather luggage, to keep my mind off my 'troubles,'" Edwin said. "And a Mr. Conant, vice-president of a leather firm, who never saw me, wrote to me and promised I could have six months credit on any leather I needed to buy," Snow wrote in his autobiography. "Mr. Nathanson, of a big hardware firm gave me the same terms." Edwin wrote that both of these men dealt him a fair deal, with "no guarantee other than my word, which had no assets beyond my faith that all would right itself." Snow had more orders "for handmade and sewed bags and cases than I could fill," he said. "Bless such men."

Soon after Albert Snow passed on, Elmer Shattuck died suddenly. Mr. Shattuck must have lived onsite because Edwin "was allowed to go unattended out to the parlor of his home to take a last look at one who was my dearest friend, the only time I ever stood beside a casket." Edwin had another reason for sadness. Warden Shattuck had been one of his most influential advocates, and with his passing Snow lost a supporter who could have helped to secure a pardon in the future.

The death of Shattuck on the heels of losing his father shook Edwin. "I shall never forget or outlive the change that came to my heart and being when I stood in silence and looked at the one who was everything a Christian and gentleman should be," Snow wrote. Fortunately, Warden Hendry replaced Shattuck and treated Edwin almost as fairly and kindly as his predecessor.

More sadness lay ahead for Snow. One hour after Judge Raymond Hopkins posted a letter to Snow, he died at his desk. Hopkins had served as Snow's junior counsel over twenty-three years before, and had kept in touch with Edwin. "My last link with my home town," Snow wrote of Hopkins's passing.

In June 1923, "exactly two years to a day from my fathers' death, my mother passed away in her sleep," wrote Edwin in his life story. Ida Huckins Snow was seventy years old and had died of heart failure. Warden Hendry offered to take Edwin to his mother's funeral, but he refused. "I preferred to remember her as I saw her last and I wished to sever myself completely and finally from the old homestead, and from the county where many people were afraid I would return and seek revenge," wrote Edwin. Ida was buried beside Albert at Woodside Cemetery on June 14. Four days later her will was entered into probate through

Barnstable County Court. Her sister, Nellie F. Whittemore, the aunt who so loved Edwin in his youth and had cared for him at her home in Middleboro, was named beneficiary, alongside Edwin. According to Mrs. Snow's will, Nellie would inherit the "homestead lot, house and buildings," worth $4,000, as well as Ida's "bonds, cash, jewelry, and furniture," valued at $1,503.01. Her furniture and household goods were left to her nieces, Mrs. Helen Andrews, who served as executrix of her estate, and Mrs. Ida Wallace Butterfield. To Edwin, Ida had bequeathed her private library.

Despite the pain of losing four people he dearly loved, and who were clearly devoted to him, Edwin continued to thrive in his prison career. In October 1923, "I left the Industry Office to do cost accounting in the Mattress Department. It was a change, offering new work and attention; and also an opportunity to aid myself materially," Edwin noted. Snow stayed on that job for five and a half years.

Edwin had never let go of the dream for freedom. If he could not walk the streets a proud young man with a wife and family, then he would try to walk the streets a proud old man, alone. In 1925, Edwin Ray Snow again applied for a pardon. The paperwork once again landed on the desk of Frank A. Brooks, the powerful chairman of the governor's Advisory Board of Pardons, the man who had presided over Edwin Snow's parole hearings in 1917, 1918 and 1925. A Republican from West Concord, Brooks had been chairman of the governor's Advisory Board of Pardons since 1916, and his devotion to his role was legendary. "Make prisoners work" was Brooks's motto. Few lifers were paroled on his watch, Edwin Ray Snow among them.

Mr. Brooks scheduled a hearing date. Cape Codders got wind of the impending proceedings and were enraged—Yarmouth residents in particular—that Snow was up for parole again. Two of his childhood friends, Charles Bassett and Edward T. Chase, again headed the Cape movement against Snow's release. Along with David Kelley, the three men composed the slate of the Yarmouth Board of Selectmen and were influential in circulating a petition against Snow's release. When delivered to Frank A. Brooks the petition read, "We believe he is an unsafe man to have liberty and we know the sentiment of his community is very strong in opposition to his being released." Letters from prominent persons in Yarmouth, Dennis and Barnstable found their way into Frank A. Brooks's office. From Dr. Gorham Bacon: "The feeling against his release is still very strong."

Writing from Yarmouth in October 1925, Mrs. Mary Knowles called the killing of Jimmy Whittemore "the worst crime in the history of our town." Twenty-five years later, the gunshots that felled young Whittemore still resounded through Yarmouth. "We do not fell [sic] that he would be a safe man to have in our society and hope that your board will consider the feelings of the

people in this matter," wrote F. Howard Hinckley, treasurer of John Hinckley & Son, a seller of lumber and building materials.

"I understand another effort is being made for the parole from State Prison of Edwin Ray Snow based upon the supposition that since the death of his parents the sentiment here has changed in his favor," penned T.T. Hallet of Yarmouth Port, the owner of a successful apothecary on Main Street. "I have failed to hear of any such change and in my opinion over 95% of our people are greatly opposed to such action."

A quarter-century after he shot and killed James Whittemore, feelings against Edwin Ray Snow ran as strong and deep as the waters of nearby Nantucket Sound. "I cannot but feel that if he were released from all restraints he would be a menace to the Public wherever he might be and it certainly would strike terror to this community if it were known that he was at large," John Clark wrote to the parole board. Another noted Yarmouth resident, Ella Williams Bray, also penned a note to the parole board. "Snow is a very bad man or a moral degenerate and therefore in either case a menace to the life and property," she insisted. Always a keen concern to Yarmouth residents was the chance that Snow would be paroled and come home seeking revenge on those who had always opposed his release. "He would doubtless come to the Cape, if freed; for he got as far as Middleboro where he escaped from prison a few years ago," Miss Bray added.

Members of the Friday Club, a charity organization founded and run exclusively by Yarmouth Port ladies, signed a petition protesting Snow's release and that document was posted in the care of Frank A. Brooks. Among the signers from Yarmouth's most northern village were Mary Thatcher, Alice Matthews, Mary A. Knowles, Carrie Gorham, Mary Baker, Lila Nickerson and Ruth Pulsifer.

Edwin Snow had at least one advocate from Cape Cod during the 1925 hearing, for which transcripts of the proceedings have not survived. Hyannis attorney John D.W. Bodfish, the distinguished blind counselor who had surfaced as a Snow detractor many years ago, found the strength to deliver lukewarm support to Edwin. "I believe he must have been suffering from some mental trouble at that time," Bodfish wrote, adding, "and if he is not suffering from any mental trouble now I believe he should have his liberty."

The year 1925 would not be Snow's year for parole. As in 1914, 1917 and 1918, Edwin Ray Snow was denied freedom and ordered to remain a prisoner of the Commonwealth. Upon hearing the news, Edwin was forced to relive all the frustration, anger and bitterness that this fourth rejection handed him. Edwin Ray Snow returned to his prison routine as a cost accountant in the Mattress Department.

He maintained a low profile between 1925, when his parole was denied, and 1930, when he again petitioned for clemency. In 1925, Edwin turned forty-two

and was in his prime working years. Charlestown Prison authorities kept him busy. Edwin kept stock and did some basic accounting work in the Mattress Department.

In February 1928, Edwin received word that Idella Rogers Whittemore had died. Jimmy's mother had passed on of "arterio sclerosis," according to records at Dennis Town Hall. Idella was seventy-five years old.

In March 1929, Edwin was "put on outdoor work as a relief from shop confinement," according to his prison work detail. A few months later, in June 1929, Edwin toiled as "a stock clerk and shipper for the Aluminum and Galvanized Ware Department." Snow gave no trouble to authorities at Charlestown Prison.

In 1930, Edwin reconsidered actions that could bring freedom. Later that year, he again petitioned for pardon. Now forty-eight years old, Edwin Ray Snow was a middle-aged man. His writings had turned reflective and melancholy. In a letter dated July 14, 1930, addressed to an old friend, Charles J. Connick of Newtonville, Edwin wrote of the day that changed his life and the lives of so many others.

"The fourteenth of September is just two months away. That day represents in my life a point of departure and, as well, the entrance to a new unfamiliar path," Edwin wrote of what would be the day after the thirty-first anniversary of Jimmy Whittemore's death. Edwin wrote of his arrest as a young man and the murder charge.

He spoke of his willingness to try again for parole, but expressed concern over the outcome of yet another parole hearing. "I am quite willing…to stand forth mentally and spiritually naked." In the letter to Connick, Edwin wrote of Charlestown State Prison. "I feel that my 'formative years' were shaped right in this prison, and that my real development did not begin until after I was committed." Edwin believed that if granted freedom, the influences of friends would lead him to continue to live a decent, honorable life. "But it is very clear today, to a plainly observing person, that success and defeat, denial and dismay, good citizenship and poor living, are very much a matter of friends and opportunities and localities," Edwin wrote to "My very dear C.J.," as Snow referred to Charles J. Connick.

"Society cares not a flip about me so long as I am in no way disturbing its wonted routine," Edwin wrote. He was convinced that if he was paroled, any locale "has nothing to dread because of my presence."

Edwin wrote to C.J. that he sought solace in books and the interpretations of each book's message. "Charlie, this afternoon I am to write a review of the eight-volume set *Progress of Nations*…It's a long journey from the criminal inclinations to a point where one can see and realize himself as a unit in a great whole," Edwin added, perhaps alluding to a renewed sense of being part of the outside community.

"To sense that there is a whole, a beautiful pattern, is about as far as any one can go in this moral life. It blots out all anti-social aims, and fulfills what is expected of the individual," Snow asserted. Perhaps Edwin thought that life should be lived within the bounds of the law and believed that through a moral life one finds liberation and happiness. "It sets the seal on his experiments, education, development, and accomplishment," Snow finished.

In the months ahead Snow would petition the governor for clemency. "I do this," wrote Edwin to Connick, "not because I consider the merits of my case exceptional, but because it seems to me that public opinion is now quiet, and that I have become fit for freedom." How very wrong that assumption would turn out to be.

9

LET ME, FOR ONCE, BREATHE FREE AIR

On January 1, 1930, Edwin Ray Snow marked the New Year by writing his autobiography for his friend, Reverend Spence Burton. Edwin did so to line up a collection of advocates of friends who were in a position to assist him yet again in his upcoming petition for parole. Having his life story on paper could be used as a reference point for his friends, who, Edwin wrote, "wish, need or can use as a basis, these absolutely true statements and records."

There are some similarities in tone and content to the 1919 life story composed by the *New Bedford Sunday Standard*. Yet it is clear from the 1930 text that Snow had matured into a reflective man and indulged heavily in sentimentality. Still the growth in Snow is unmistakable. "It is said that the reserves of Nature are inexhaustible," he wrote. "It may also be said, with truth, that so are the reserves of human nature." Edwin said he had found that as the years rolled by, he could handle in middle age circumstances that he had found intolerable as a youth. "As we grow into life, losing what we thought irreplaceable, doing what we felt was irreparable, being what we imagined was irrevocable, human nature never, ultimately, let us down," Snow humbly wrote. Nearing fifty had apparently turned Edwin into a jailhouse philosopher.

Dated the first day of January 1930, the autobiography is the first known "life story" Edwin composed since December 1919, nearly a month after that infamous short escape from Charlestown State Prison. The nine-page document is a compelling read. Edwin revisited his life from his perspective. It is a seminal emotional paper in understanding him.

"Exactly thirty years ago today, I was sentenced to die in the electric chair the following March," Edwin begins, adding, "I was the first person sentenced to die in the chair [in Massachusetts]." Edwin probably chose to begin at the point entering Charlestown Prison, since the life story's aim was to get him out of that Boston facility. "No man so sentenced has received executive clemency," Snow wrote. "I would say, from memory, not more than ten have had the

death penalty remitted. The next in succession is several years behind me; and a number have died a natural death." Snow also said that several inmates at Charlestown Prison sentenced to die by hanging, and commuted to life, were later pardoned with parole conditions.

Edwin wrote that all the Cape Cod principals involved in his case had died. "The judges, district attorney, attorney general, police officers, and my senior and junior counsel, are all passed away." Remembering those days, Edwin said his death sentence had been commuted on January 8, 1900, and a week later he began to serve a life sentence. "Governor Murray Crane and his Council visited me, one week after their action, and told me that because of my youth they felt I had had 'a bad start in life,' and that 'some day you may have your chance as a man,'" remembered Edwin. That is also the message Snow received from his junior counsel, Raymond Hopkins, which led Snow to appeal for parole as early as 1914.

"I seek clemency," Edwin wrote to his friends, "that will lower my sentence to 45 years, and grant me a present parole, 2/3, retaining 'life' as the maximum, or pardon with parole conditions," Snow added.

Edwin had been imprisoned for over thirty years, and felt his plea for pardon was justified. "I am close to fifty years of age," he wrote. "I have spent thirty-one years and two months in a prison cell. I do not believe it is any part of any scheme or purpose of God, Nature, Humankind, Society or Law, that a mere boy of 16 shall live and die in prison, without ever having had one single chance as a mature man in the free world."

Edwin Ray Snow had to have known that his parole application greatly depended upon the courage and support of his advocates. "I will obey any condition and control that is imposed, but let me, for once, breathe free air," he pleaded.

As the polished writer he had become, Edwin divided his life story into succinct chronological chapters, beginning with his boyhood. "The first sixteen years of my life were spent in a home in Yarmouth, Mass., known as a part of Cape Cod," Snow began. "I can remember an old sea-captain, my mother's father; my grandmother on my mother's side; four brothers and two sisters of my father; and my mother's sister's family," Snow recalled. As Edwin had always done, he wrote glowingly of his parents, the late Albert C. and Ida Snow. "My mother and father had a perfect married life; and a home the equal of any other I ever visited," Edwin fondly recalled. "During school vacations I went to my aunt's in Middleboro, and a few times with my mother to Brockton, Dorchester and Boston. Not one person on either side of the family, mother's or father's was ever implicated in any crime or dissipation or scandal or debt," he proudly wrote. Ultimately, the relocation to Middleboro proved to be the foundation of all of Edwin's troubles.

While my home life had been guarded and strict, I was suddenly—because my aunt had five children to watch and train—given a very free rein in a much more exciting town. I went with many girls of high-school age, and with a tendency to show off or a fear of losing them I spent more money than I earned or was allowed. I planned no crimes, and had no confederates; and I do not recall a boy in Middleboro who ever did suggest such things.

Snow recounted in the 1930 autobiography for Reverend Burton and his other advocates that he and his friends were "earnest young chaps, whether in gym or prayer meeting."

It would have been an understandable omission for Edwin not to discuss the indiscretion that caused so much trouble for him, i.e., the 1907 "unnatural act' with the Cuban inmate. Instead he wrote, "The man who committed the act was held only twenty days at the end of his minimum sentence."

As mentioned before, Edwin was allowed to sit in on that 1918 public hearing, and question those witnesses who opposed his bid for freedom. "A message came that I was to sit in the Board Room and hear and question every witness [a procedure never followed before]." Snow claimed he had not had a lawyer present; his attorney had been called away the night before. Edwin saw the irony of the 1918 public hearing. He had the freedom of questioning witnesses, but had no legal counsel present. "My parents sat on either side of me and cried every minute," he recalled. "A delegation of neighbors who had always promised to help them were worked up and enjoined to oppose me," Snow claimed. Their refusal must have been a crushing blow to Albert and Ida Snow, one that caused them considerable agony throughout the hearing.

I had to sit in their presence, they who had not seen me in a score of years, and keep my temper down; I had to sit and hear men who had coached me for years, been father and mother to me, made face-to-face promises to me, been wholly unfamiliar with a single private thought or aim, I was compelled to sit there and hear them deliberately and maliciously testify to untruths and take a public stand just the reverse of their man-to-man one.

Every officer I had worked for, the warden, deputy, assistant deputy, steward, clerk, chaplains, each and every one recommended my release. After the hearing I asked the executive secretary for a copy of the testimony of these gentleman and he was told the stenographer had died and the notes were not complete. Yet there were two stenographers at the hearing. Even on the last day the retiring counsel wrote me they would still vote my release, but Governor McCall was sick, and the report was held back till Governor Coolidge took office, and I realized then what I had been unwilling to believe, that the faith and belief and trust and ideals of a lifetime were dragged in the dust.

Edwin felt cheated and angry.

Snow chalked up his 1919 prison escape merely as "an impulsive wanderlust, a temporary aberration." Quite different, he theorized, "from the selfish, anti-social, murderous scheming of a confirmed criminal." Nevertheless, the latter is exactly how critics of Snow interpreted his "wanderlust." As he had in 1907, Edwin paid a dear price for breaking the rules.

Snow wrote of losing his father, Warden Shattuck, his mother and boyhood counsel, Raymond Hopkins, in the early 1920s.

In the fall of 1923 Edwin had left the Industry Office "to do cost accounting in the Mattress Department." The change was a welcome one for Snow, "offering new work and attention; and also opportunity to aid myself materially," he wrote. Edwin stayed on the job for five and a half years. Toward the end of the 1920s, Edwin assumed the role of "stock clerk for the aluminum department, a job that is less sedentary, and one of the most trusted positions an inmate can hold. It is exceptional for an inmate to have so many different positions, but I do feel that it has all been fine training and restorative in a great degree, enabling me to maintain a healthy enthusiasm for work, and an unexaggerated sense of my losses," Edwin wrote in 1930.

"When death took my father and mother, the center and focus of all my thoughts and wishes, I looked about in helplessness for a like standard and support," wrote Edwin. "If thought-wishes can travel, and do link up, then mine made a quick straight trail," he noted. Edwin spoke of a "message" from "a man and a woman up in Canada, whose name I had never seen or heard." This is Edwin's first reference to a couple up north, whose names have never appeared elsewhere in documents relating to the case. Edwin apparently grew close to the couple, for he wrote,

> Dear as one's parents are, they do not possess all the qualifications upon which we rely for development. We do make graven images and mental conceptions... This year or so following my mother's death I met these two people I have referred to. And from that day to this day they have fulfilled my ideal of a perfect friendship. It is true I get from them about ten times what they could possibly receive from me, because I have only them to draw on, while they have the whole world to select from.

Snow's 1930 autobiography mentioned another woman to whom he had grown close, believed to be his cousin, Mrs. Helen Andrews. "She entered my home when I left, and was trained as I was trained and she has remained true to it," he recounted. Albert and Ida had taken in another child after Edwin was incarcerated at Charlestown Prison, a girl considerably younger then her stepbrother. She was "a noble-hearted woman, but, as often happens in a

dizzy world, not as prosperous as some with a lesser merit and a flabby code," he said of this woman, presumably Helen Andrews. "Blood is stronger than water and even though I was adopted, and we have no natural physical unity, it is undeniable that one's home circle has a pull nothing can supplant," Snow noted. Edwin apparently stayed in touch with his foster mother's other charge. "I rejoice in this one attachment that keeps dad and ma ever with me; and I pray the day may come when I can help Helen as she helped my mother in her last two years."

Edwin's adult relationships were "quite a contrast to those of my boyhood,' he admitted. As a youth, Edwin focused too much on owning things. "The 'my' was too evident in every relationship, a supreme form of confinement, preservation, selfish ownership. Neither friendship or Christian practice can endure the strain," he noted.

Many people entered Edwin's widening circle of intimates as the 1920s waned. "I look over my Xmas cards," Snow said while writing his life story on January 1, 1930. "Messages from Russia, France, India. Messages from California, Pennsylvania, Rhode Island, and ten different parts of this state. No 'slushy, sloppy sentimentality' for a 'poor prisoner,' but honest, earnest, robust fellowship reaching out across time and space and condition." Clearly, Edwin was delighted at not feeling totally alone.

It is at this point that Snow concludes his autobiography. However, Edwin did include a list of goals to pursue if parole was granted. Edwin Snow wrote in 1930 that "an educated man has two purposes: to gain knowledge and to serve his fellow man." Edwin, as he described himself, was generous with money. "In addition to my service as shop instructor, and as school teacher, it has been my privilege and joy to aid men here with money, fill a need, buy a musical instrument, supply books, etc." A self-taught man, Edwin claimed to have read three daily papers, three weekly papers, twelve weekly or monthly magazines and journals, several technical or trade publications and a total of six thousand books, classics, biographies and modern "populars." According to Snow, "I think a man may acquire more than a university education this way."

Edwin claimed never to have gambled or squandered his earned funds. Cash was a rare resource for Snow; it had always been so. "I find that I have earned approximately four thousand dollars," Edwin claimed. "I have spent one thousand for books and magazines for myself and others; two thousand for necessities; and given away one thousand," he noted. "One can never measure the influence and results of such acts, or what response they awake." On the last page of his correspondence, Snow wrote, "I made a covenant with myself that I would serve 30 years face to the front, head unbowed. I read this morning that only one man in an Ohio prison, in a population five times this one, has served longer than that."

In 1930, Edwin was in his late forties and worried for his health. "The strongest physique must give in some time; decay begins and works fast. Only two men are here more years than I," Snow explained, for he had become an elder statesman of Charlestown, far from the boy of seventeen he had been when he arrived in 1900. "I do not think I have scaled over or left out a single factor that has prompted my appeal for mercy," he added.

Freedom was all that Snow asked for in this stage in his life. Surely, he must have given up the notion of marriage and family, given his age. "Sexual interests are all dead. Gambling, liquor, vice do not attract," Edwin claimed. "Just to wear a suit of clothes; and go freely through an unlocked door is all I ask of the future."

Edwin, in a rhetorical question, asked, "Of one hundred 'murderers' who have left this prison since I entered it, not one has repeated his crime. Why assume that I would?" Snow had a point. Perhaps if not for the heavy opposition of Cape Codders, there might have been a chance for Edwin to win his freedom. "Hundreds of men come here, remain on one single job, stay in one single cell, make one single alliance or contact, and then go back to the world, not a habit or belief or thought or intention changed," Edwin reasoned. "If my record does not show a sound or definite growth away from a boyhood foolishness, it shows nothing at all."

To Father Spence Burton, Edwin's central supporter, Snow wrote,

> *Our Father may this plain, sober sincere account be read by people who have thy spirit to help them see and feel what it represents. I have written with reluctancy; and may there never be cause for me to revert to what has been set down.*
>
> *Signed Edwin Ray Snow.*

10

A PLEA FOR MERCY

On December 6, 1930, Snow wrote to Governor Frank G. Allen requesting another parole hearing. He felt confident of his chances. "I hereby, your Excellency, humbly ask that you spare me a short period of your thought, and also grant me a hearing at which others may present the impressions, convictions, and knowledge, perhaps claims of merit, that have formed by years of contact, control, and observation," Snow appealed. Edwin flattered the governor and appealed to his sense of compassion when he wrote, "I have such confidence in your character and impartiality! And, likewise, a belief that this is an opportunity that will never be mine again."

Edwin enlisted his advocates to gear up for another hearing. In turn, these supporters mustered prominent citizens to help in Snow's battle for freedom. In a letter dated July 30, 1930, Boston Mayor James Michael Curley, at the behest of Charles J. Connick, a close friend of Edwin's, appealed to Governor Allen to free Inmate #12673. "I feel it needless to dwell upon the extreme youth of the man at the time of commission of the crime or the number of years that he has served as prisoner at the Charlestown institution," wrote Mayor Curley. "It is sufficient to say it might be an incentive to better conduct and to the hope for reward for the same, on the part of the other inmates, provided a parole were granted in the case of Mr. Snow."

One by one, the Advisory Board of Pardons heard supporters of Edwin Ray Snow again speak of his rehabilitation, his intelligence and his journey from juvenile delinquency to mature manhood. Thomas C. O'Brien, a former district attorney for Suffolk County, said of Snow, "I observed him as a steady earnest man who was trusted to the limit." The Honorable W.W. Lufkin, a former Congressman, testified "that the state has made over [Snow] from an 'irresponsible worthless vicious boy' into a mature man."

Charles J. Connick, the recipient of a poignant letter from Snow in September 1930, said Snow was like a brother to him. "C.J." met Edwin

through their mutual friend, the Reverend Spence Burton, and was a nationally known master craftsman of stained glass. Mr. Connick believed that "the most splendid modes of expression that the human being has" are through the arts. He said he saw in Snow a master craftsman like himself, given Snow's talent working with leather. "Such men are all too rare," said Connick.

A former Cape Codder, Everett W. Hinckley of West Somerville, also testified at the December 1930 parole hearing. The former Osterville resident said Snow did not complain about a thing. "I picture Edwin Ray Snow today as a man fully developed," Hinckley noted.

Another Somerville resident, Charles Wheeler, was introduced to Edwin in 1921, when he engaged Snow in clerical work at Charlestown. Wheeler, now an accountant in the state auditor's office, called Snow a professional. "I never thought of him as being a prisoner," said Wheeler.

Another close friend of Edwin Ray Snow's to testify was Richard Fuller, vice-president of the Old Corner Book Store in Boston. Snow had been a customer there for ten years. "I find no record of his ever having purchased or been interested in the so called sex novels or light trash," reported Fuller. Since 1927, for instance, Fuller noted that Edwin had purchased titles such as *Life of Jesus*, *Travels in Arabia Desert* and *National Geographic.* "I am interested in what a man reads when he is behind the bars and whether that reading is to while away the time, or whether his reading is of the type which shows a mind seeking knowledge and an understanding of the more serious questions of the day," said Fuller.

The little girl who had come under the charge of Albert and Ida Snow after Edwin left for Charlestown State Prison, now Mrs. Helen Andrews, was called to testify, and she did so willingly. The same mother had brought up both Edwin and she. When Ida died, Edwin signed over his portion of her estate to his stepsister, Helen. "I think he is certainly a wonderful man," she noted.

From inside the prison administration, Snow found a friend in Corrections Commissioner A. Warren Stearns. "I believe there would be no particular danger in releasing him," he said. "The arguments against release are based almost entirely upon the character of his crime and the fact that he was originally sentenced to be executed." Warden James Hogsett echoed Stearns's sentiment. "When I have a very particular piece of work to be done I get Ed Snow," said Hogsett.

Father Spence Burton assured the parole board that if Snow were freed, he would personally take Snow to California, where a job as a custodian at a fruit ranch in the Santa Cruz Mountains awaited him.

As expected, Cape Codders sent a representative up to Boston to decry the possibility of Edwin Ray Snow's parole. In 1930 "the opposition was represented by Honorable Donald W. Nicholson, a state senator from the Cape,

and testimony was given by Selectman Charles R. Bassett," noted Frank Brooks in his report on the hearing.

Bassett, a childhood friend of Edwin's, said Snow would always be a menace to the community. Bassett presented the Advisory Board of Pardons with several petitions from the Cape, including the Men's Community Club, the Yarmouth Grange, the Friday Club of Yarmouth Port and a "special resolution" passed at a special town meeting in Yarmouth in which three hundred people present voiced concern over Snow's parole.

Despite receiving glowing reviews from advocates off-Cape, many of whom had known Edwin intimately for decades, Cape Codders took a dim view of these character accolades. "The boy is father to the man," claimed State Senator Donald W. Nicholson. "If a man is a sneak when he is 11, 12, 13, or 14, and 15 years old, and keeps it up in him and in his bones and in his marrow." State Representative Francis H. Perry of Brewster was among many of Barnstable County's leading citizens to oppose Snow's pardon bid in 1930. "I feel sure that nine tenths of the people on Cape Cod feel as I do about this matter. I think it would be a great mistake at this time to pardon the above Snow," insisted Perry.

Indeed, it proved to Snow that even after thirty years Cape Codders had a long memory and that they continued to believe that he was simply evil. "I would like to say I was living in Yarmouth at the time of the murder," explained Dr. Gorham Bacon. "In fact, I rented a house at the time for the summer next to the one where the Snows were living." He went on, "I knew the boy and knew all about his antecedents, and knew all about what he had done at the Cape. I feel from what I know that it was a premeditated murder."

Mr. Chester Whittemore, a brother of Jimmy, said he was unaware that his mother had visited Snow at Charlestown in years past, and seemed surprised that Idella had gone as far as forgiving Snow. Whittemore, now living in Everett, appeared lukewarm toward any parole for Edwin.

For every witness Edwin's camp had produced in favor of his freedom, Cape Codders had two to challenge parole. "I personally should feel a very tender sense of my security if a pardon be granted to Snow," testified Theodore Swift, post office inspector of Yarmouth.

From Mrs. Mary T. Knowles of Yarmouth came angry words against Edwin. "The people here feel they know Edwin Ray Snow better than those who are trying to have him pardoned," she wrote. "Some of the teachers he went to school with as a young boy say he was bad at the start, he was always doing mean things and so the cold-blooded murder of his boyhood stands out in the memory of the people of Cape Cod and always shall."

The district attorney for the Southern District of Massachusetts, which represented Barnstable County, was William C. Crossley. Crossley, whose office

in Fall River was notified of the hearing, mailed a letter to Boston in which he stated that State Officer Ernest S. Bradford, "who is attached to my office in Barnstable County, had informed me that he has upon one or two other occasions furnished the Advisory Board of Pardons with all of the information which he had in his possession in connection with said prisoner."

Bradford was the officer who first stated in 1914 that Snow was unfit for parole then, and would plead his case in the same vein again.

Warden Hogsett asked two doctors to examine Edwin Snow. Joseph McLaughlin, the longtime prison physician who had known Snow for nearly thirty years, wrote that Snow "appears to be in very good physical and mental health." In addition, Dr. Charles B. Sullivan of Boston examined Snow and noted that Prisoner #12673 "had been a model and useful prisoner, been able to adapt himself to any and all positions in which he was placed, and seems to have successfully accomplished everything he was assigned to." He also claimed, "He showed no evidence of any neurological or mental disability, was pleasant in manner, has good social adaptability and intellectually seems to be capable of being able to care for himself."

Edwin testified at his own 1930 parole hearing. Based on existing transcripts available at the Massachusetts Archives, Snow's replies to queries about his work in the prison industries were simple and respectful.

"Is there anything further you want to say?" Snow was asked. As he had done so many times before, in 1914, 1917, at the public hearing in 1918 and in 1925, Edwin drew a deep breath and continued to speak.

"I realize the horror of it just as acutely as anybody does," Edwin began, referring to the slaying of young Whittemore. "I have lived with that memory a great many years (until I was privileged to meet the mother of the boy and I obtained her forgiveness). I have done everything in my power to develop myself," Edwin pleaded. "I have seen a hundred other life men go out. I felt I could apply for mercy. I don't ask for anything else."

Edwin agreed that society cannot forgive the crime of murder, and yet, he said, "there is such a thing as mercy." Snow said it would be impossible for him to commit the crime of murder again in 1930.

"You have seen the mother, Mrs. Whittemore?" Frank Brooks asked Edwin.

"Yes," came the reply, "Mrs. Whittemore came here, I think it was in 1918. I wrote to her and she came up simply on the strength of that letter, with her pastor from down on the Cape...she talked with me, and I considered that hour something that is too sacred to bring out and discuss," replied Snow. Edwin was asked how long he had known "Jim Whittemore," and he replied, "I knew him as the driver of the bakery wagon that went through Barnstable two days a week." Edwin told the parole board he had ridden with young Whittemore many times if he wanted to go to Hyannis.

Edwin testified that the day he had killed Jimmy was the first time he had seen young Whittemore in "18 months probably." Their ride together on that fateful day was pleasant; the two chatted and Snow said he found Jimmy to be "a kind fellow." However, when asked why he shot Whittemore, Edwin told the parole board, "I don't think I could reproduce it today."

After Edwin testified, his lawyer, Mr. Evarts, was given time to speak in his client's defense. Evarts called Edwin a man of intelligence. Snow might not be an educated individual, but he was, according to Evarts, a self-taught man of "fine production." A man such as Snow, if freed, would make a productive member of society. "There is no reason to suppose he will commit murder under normal circumstances of life on the outside," his attorney reasoned. Evarts said Snow was completely reformed "so far as the people who know him now can say." As for Cape Codders who vehemently argued continually against Edwin's release from Charlestown, Evarts said they simply did not know Edwin, "who come out with the determination of keeping him in prison because of unreasoning fear."

Evarts said that the State of Massachusetts had done a fine job in rehabilitating Snow, and it was time to let him go. "Confinement of this nature, if taken beyond a certain point, may, very likely result, I should assume, in mental and moral deterioration. He will give up hope. You can imagine being in prison thirty or forty years," Evarts continued. "He would be all right at the end of thirty years, but pretty near crazy at the end of forty."

Evarts then struck a nerve with the parole board and Snow's critics. "I would be willing to guarantee if this crime were committed in 1899 in the streets of Boston or Cambridge, there would be no opposition to this man's release," he said, adding, "You can see what you are up against solely on account of the accident of location, which is, of course, an unjust condition of affairs."

Speaking on behalf of the opposition, State Senator Donald Nicholson reiterated Cape Codders' fears about Edwin Snow's possible release and insisted it was his job to address those concerns. "They have a certain dread all the time that this man would show up in that community again—to these people in the community, thirty years is not a long time," said Senator Nicholson.

Chairman Frank Brooks concluded Edwin Snow's 1930 parole hearing. In a letter to Governor Frank G. Allen, Brooks released his recommendation three days before Christmas, on December 22, 1930. "A majority of the Advisory Board of Pardons taking into consideration the commutation that Snow has already received and all the above facts are of the opinion that clemency should not be shown, and therefore, respectfully recommend that your Excellency do not grant a pardon." If there was a silver lining, it is that one member of the advisory panel disagreed with Brooks, but failed to garner a majority vote.

Edwin was devastated. He spent his thirtieth Christmas in a prison cell at Charlestown Prison.

A Plea for Mercy

One supporter remained undaunted. In a letter to the governor's office, Father Spence Burton wrote, "There is no danger of my losing interest or confidence in Snow. He and I have been intimate friends for twenty-five years and I shall never cease my efforts for his release until I have him out of prison."

11

WITHOUT A
BACKWARD GLANCE

By the early 1930s, Edwin was in his late forties and was a clerk in the prison industries. In his off hours, he crafted leather goods in his prison cell, corresponded with supporters and met with friends. Never did Inmate #12673 give up hope to one day go free, and neither did his strongest advocates.

"The only opposition which has appeared against Snow's release in the past has come from a small group in the Town of Yarmouth, where the crime was committed, who have taken the stand that if Snow was released he would likely return to Yarmouth and wreak vengeance upon the inhabitants of that community," wrote a longtime Snow friend, former Congressman W.W. Lufkin, in a letter to Massachusetts Governor Joseph B. Ely.

Lufkin had befriended Edwin twelve years earlier, and pleaded with Governor Ely to free Snow. "During his confinement Snow has seen prisoner after prisoner—many of them guilty of much more brutal murders—released, while he apparently can see no hope, in all probability because the crime was committed in a small community where people are not prone to forget and forgive," added Lufkin.

Two weeks after Lufkin wrote the letter to Governor Ely, Edwin spent his thirty-second Christmas at Charlestown State Prison.

The winter of 1932–33 passed slowly for Edwin, who worked on another campaign for parole while recuperating from a "shock," or mild stroke. Among his ardent supporters was Warden James Hogsett, whose job it was to keep Edwin Snow incarcerated. Over the years, Hogsett had come to know Snow well, indeed put much trust and stock in Inmate #12673. In a letter to Governor Ely the warden insisted the time had come to free Edwin. "Snow has had a splendid record during his thirty-two years in prison," wrote Hogsett. "He has saved the state considerable money during the time he has done clerical work, and I consider him capable of filling a responsible position if released."

In the spring of 1932, Edwin again applied for clemency. "I hereby humbly petition you to extend to me the mercy and forgiveness of the State, as recognition of my attempt to atone for my crime," Edwin petitioned.

Edwin's former sweetheart, the devoted Eloise Doherty, now Mrs. Sheehan, assisted Edwin in his renewed quest for pardon in the spring of 1932. It was in her steady handwriting that letters to governor Ely were composed to reassure His Excellency that Edwin had obtained the forgiveness of the Whittemore family. "He has begged us, the brothers and sisters, to forgive his crime, and the great grief, loss and suffering by our family because of his crime," the letter read. "He has used no means or methods to effect our opinion or wish except a direct, humble, penitent appeal for our mercy." The letter was signed by the surviving brothers and sisters of Jimmy Whittemore: Harry Whittemore, Hattie Chase, Sarah Small, Chester Whittemore and Edward E. Whittemore.

Protocol demanded that opposing parties on record be notified. In April, Honorable William C. Crossley, the district attorney for the Southern District of Fall River, was alerted that "the Committee on Pardons, Charitable Institutions and Prisons of the Governor's Council" would hold a hearing at the council chamber on April 20, 1932, at 10:30 a.m. on the petition for pardon for Edwin Ray Snow. It must be assumed that those Cape Codders who in the past opposed Snow's parole attempts, men such as Edward Chase and Charles Bassett, were also briefed about the upcoming hearing.

Unfortunately, transcripts of the proceedings do not exist as they did from past sessions of the Advisory Board of Pardons. A shame, given Governor Ely's decision to grant Edwin Ray Snow a pardon the very day he applied for it, despite a recommendation to deny parole by the State Advisory Board of Pardons.

On April 2, 1932, Edwin Ray Snow strolled out of Charlestown State Prison for good. By day's end, he would have been processed out of the state prison system, no longer Inmate #12673. Word of his impending freedom must have spread through the prison population as fast as news of his jail escape nearly thirteen years earlier.

The *Boston Globe* reported,

> *Saved from ending his days behind prison bars, Edwin Ray Snow, once of Yarmouth, an alert, self possessed man of 50, walked calmly out of the Charlestown State Prison last night, a free man after 32 years as a "lifer." He drank deep of the Spring air and threw his shoulder back. His eyes roved quickly to the traffic about him. He ran his fingers over the new suit that so recently had replaced the drab gray of the prison inmates. Without a backward glance at the grim walls he stepped into a State automobile and drove with William M. Robinson, agent for the pardons board, to the State House for his final papers of release.*

As chairman of the Advisory Board of Pardons, Frank A. Brooks signed the papers on behalf of a man who had gained freedom against his recommendation. This time, Brooks was powerless to do anything to stop Snow's release.

"When Mr. Robinson drove him at 6:30 to the State House office of Chairman Frank A. Brooks of the Pardon Board, Snow was as easy and free in his manner as the group of newspapermen who awaited him," cited the *Globe*. "He posed for pictures with all the calmness and amiability of a seasoned traveler, and talked without restraint and without annoyance."

Hovering near Snow was the loyal Father Spence Burton. It had become Father Burton's mission to see that Edwin was granted pardon, and finally that day had come. Edwin agreed to be interviewed by reporters. "It all came to me so suddenly that I am almost bewildered," Snow declared. "Of course, I have prayed and hoped for years that this commutation would be granted me, but I did not think it would come with such swiftness."

In past years, Edwin waited days, even weeks for a decision regarding petitions for parole. This time around, Snow had an answer within hours of the hearing, so very unlike the five previous parole hearings in 1914, 1917, 1918, 1925 and 1930.

Edwin declared,

> *I have no particular feeling of strangeness about being out in the world again after all these years, for I have kept closely in touch with the affairs of the Nations and the world by reading the best books and the best magazines that I could obtain. I have read all the best authors, on philosophy, science, religion, language, everything I could get. For 12 years I taught in the prison school, common school subjects, Spanish, anything they wanted me to do.*

A reporter remarked that Snow looked fit, that he seemed in good physical condition. "Well, I am going to try my best to make the most of my remaining years," replied Snow, "and it has taken 10 years off my life in the past few hours, this good news."

Snow's parole had conditions. He was ordered to "report at regular intervals to the Massachusetts authorities. Any violation of his parole would send him back to Charlestown," the *Globe* reported. Father Burton gently nudged Edwin's arm and the pair prepared to leave Frank Brooks's office. As the longtime friends departed the State House, Edwin turned to a reporter and said, "You may be sure that I [will] make the most of my life from now on."

Edwin Ray Snow spent his first night of freedom, April 20, 1932, at the Boston headquarters of the Cowley Fathers on Bowdoin Street. That night Father Burton finalized plans for his friend's future. With Snow's consent, he would move to California to work "in the San Francisco branch office of the

Society of St. John the Evangelist, and also on a California fruit ranch of which I am a trustee," Burton wrote in a memo to Governor Ely.

The reaction from the Cape was curiously calm and devoid of the furious passion that had ignited formal protests in 1914, 1917, 1918, 1925 and 1930. The only word from the *Register*, long the chronicler of the Snow saga, was, "Governor Ely has placed upon parole Edwin Ray Snow, formerly of Yarmouth Port, a life prisoner at Charlestown, who served 32 years of his term for murder. His release was obtained largely through the persistence of Rev. Spence Burton of the order of the Cowley Fathers," the article added. "Snow expects to leave for California where permanent employment awaits him."

With that, a three-sentence story, the local establishment laid to rest its arms in the Snow battle. No petitions, no formal protests, no leading citizens mustering in to fight Yarmouth's perennial battle against Edwin Snow were mounted. The silence of his former neighbors may have surprised Edwin more than learning of his freedom the very day of the hearing.

What is even more interesting is the article's omission of the name of the young man Snow had murdered—the person whose memory had become a local icon. The name of James A. Whittemore failed to garner a mention in the short *Register* article announcing Snow's release in April 1932. Had he lived, Jimmy would have been fifty-three years old.

For years, Whittemore's memory was the classic example of an innocent victim of a crime. His shooting had ignited a fire that had burned the community's passion for three decades. Yet, it would seem that the community machine fueled by hatred and fear for thirty years had finally run out of steam.

Edwin spent the remainder of April and most of May under the watchful gaze of the Cowley Fathers home in Cambridge, where Father Spence lived and presided over Boston-area Episcopal priests. Edwin had emerged from Charlestown a free man, but ill equipped for living in the twentieth century. Those weeks may have entailed grooming Edwin for the outside world: what clothes to wear, how to handle routine situations, how to order food in a restaurant.

Most likely Edwin followed news from "home" after his move to California. He would have learned of the death of Frank A. Brooks, his institutional enemy, on April 19, 1945, "after an illness of six weeks," according to the *Boston Herald*. He was eighty years old. Whatever Edwin Snow felt about Frank Brooks was a mystery. The man who held such power over him for over fifteen years had by all accounts treated him fairly. Snow was given leeway in addressing parole boards, including a chance to question his detractors at a heated 1918 public hearing. The last time Edwin Ray Snow had laid eyes on Brooks was in April 1932, the evening when Frank, acting in his capacity as parole board chairman, signed the paperwork that freed Snow.

By early summer, Father Burton had taken Edwin to live in California, where he worked for the Cowley Fathers for about a year before striking off on his own. It isn't known why Snow left their employ, but by all accounts Edwin left the Cowley Fathers on good terms, given his lifelong devotion to them.

In April 1933, nearly a year after he left Charlestown Prison, Snow found work at the C.I. Malm Company. In this new job, Snow found acceptance, fellowship and an outlet for the skills he had obtained in prison. Edwin was, at fifty-one, faced with a dilemma of whether he should tell his new employer about his past as a prison inmate, thereby risking his job security. Edwin eventually told his bosses everything once he established himself as a competent, trustworthy worker. The owners at C.I. Malm took the news in stride. Edwin kept his job and was entrusted with additional responsibilities in the coming years. Snow must have known that problems would crop up here and there, and they did. Even free men have their troubles. Around November 1933, most likely due to depression, Edwin fell onto hard times.

Perhaps the starting wages weren't enough to support even a meager lifestyle. In this time of crisis, Edwin turned to his former "family" of Charlestown prison inmates in which he had lived for thirty-two years, and they did not fail him, though he lived thousands of miles away from Charlestown. That month Snow received a letter from "home."

James Hogsett wrote on November 18, 1933,

> *Dear Snow,*
>
> *I am very sorry for the predicament you are in at the present time. Some of the boys are sympathetic, as you will see, and we are sending you a small amount to tide you over the hard spot, I sincerely hope something breaks for you soon. Let me hear from you in the near future and it is possible we can do more if you do not find work.*
>
> *With deepest sympathy, I am very sincere, Warden.*

Two collections in as many days netted Snow thirty-three dollars, or roughly a dollar for every year at Charlestown Prison. Even Hogsett's wife threw in two dollars for Edwin. Eventually Snow found his footing at C.I. Malm. As the years passed, Edwin shifted to several other positions, and each new post could be seen as a promotion. Snow would eventually rise to credit manager.

Edwin's daily life in San Francisco is a mystery. We know only that he eventually settled at 701 Pine Street. It is likely that he occasionally visited with Father Spence Burton and other advocates who had been so kind to Edwin in the past. After thirty-two years in prison, even a dull day in the city by the bay must have exhilarated Edwin. His luck was to continue.

Without a Backward Glance

Edwin Ray Snow fell in love with Virginia De Long, a native of Imlay City, Michigan. According to Snow's parole file, Miss De Long came from a wealthy retailing family. Virginia worked as a secretary at the Industrial Indemnity Insurance Company in San Francisco. Little else is known about her, and how the couple met is uncertain. In any event, Edwin Ray Snow married Virginia De Long on May 30, 1943, in San Francisco. The bride was thirty-eight, the bridegroom was sixty. By all known accounts, Mr. and Mrs. Edwin Snow had no children. The Snows shared six years together before Edwin fell ill with cancer.

For the last nine months of his life, Edwin was ill and in great pain. Virginia, in a letter found in his prison file neatly composed shortly after Edwin's death, wrote to Martin Davis, his parole officer in Massachusetts, and said nothing more could have been done for him, and his passing had been almost a relief.

As he lay dying at St. Luke's Hospital, Edwin Ray Snow was visited by Father Spence Burton, his friend and confidant of twenty-five years.

Edwin Ray Snow died a free man, a retired leather craftsman from California, of prostate cancer and cardiac failure on April 22, 1949.

Following his death, Virginia had Edwin's remains cremated at Woodland Memorial Park at 4200 Geary Boulevard in San Francisco on April 25, 1949. No obituary was published to commemorate Edwin's life, at least not in the major newspaper of San Francisco.

Snow was sixty-seven years old.

Had Jimmy Whittemore lived, he would have been seventy-one years old.

Virginia De Long Snow remarried, remained in California and is ninety-eight years old.

Edwin's life becomes a study of the persistence of human nature. In his younger years, Snow long claimed to be the victim of "frame-ups" and was on the receiving end of human unkindness and misunderstanding, fear and loathing. Even at the lowest ebb of his life, when Edwin had few friends, no money and was an outcast among outcasts, he continually crawled his way back up. Clearly, Edwin Ray Snow was a flawed human being, often arrogant, headstrong and deceitful, especially in his youth. Yet through the years Snow developed a more compassionate and insightful nature and became a self-professed spiritual man whose identity was forged in part in the loneliness of a prison cell.

While still at Charlestown State Prison, Snow wrote a friend in 1930, "When it comes my time to cease this earthy existence I would that it may be my lot to be with the friends who love me and believe in me. Before that time I would that I may spend a few years, as a man grown, matured individual, among the beauties and appeasements that the homes and activities of these friends offer."

For Edwin, his dream had come true.

Other than his ashes and a musty, fraying prison file, there remains today little evidence that Edwin Ray Snow walked this earth.

In November 1955, Charlestown State Prison closed, following an inmate riot in January over deteriorating conditions at the aging facility. "Penal history was made in Massachusetts today as the long delayed shift of inmates began from the State Prison at Charlestown to the new institution just off Route 1A" in Walpole, noted the *Boston Globe*.

With its demolition, a thousand stories of inmates' lives and their paths toward trouble lay under a ton of rock and iron.

ABOUT THE AUTHOR

Theresa M. Barbo has written and lectured on Cape Cod history for fifteen years. She is the former history editor at the *Cape Cod Voice*, a newsmagazine serving the Lower Cape. She is founder and president of the Cape Cod Maritime Research Association, which sponsors the annual Cape Cod Maritime History Symposium, a key event of Cape Maritime Days. She is director of the Cape Cod Bay Ocean Sanctuary Program at the Provincetown Center for Coastal Studies.

Theresa holds BA and MA degrees from the University of Massachusetts, Dartmouth.

Theresa and her husband, Daniel, reside in Yarmouth Port with their children, Katherine and Thomas.

Visit us at
www.historypress.net